ROBERT

FICHTER

PHOTOGRAPHY AND OTHER QUESTIONS

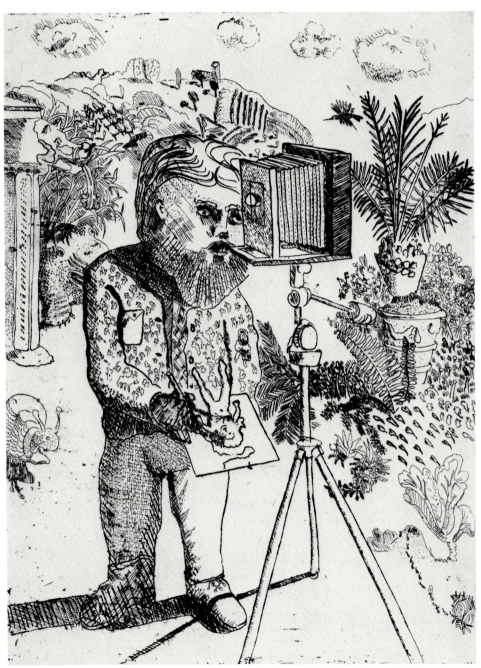

DAGUERRIAN ERROR, 1971
Collection of the artist (Cat. no. 98)

ROBERT

FICHTER

PHOTOGRAPHY AND OTHER QUESTIONS

Edited and text by

Robert A. Sobieszek

Preface by

Kenneth Donney

University of New Mexico Press
Albuquerque, New Mexico

International Museum of Photography
at George Eastman House
Rochester, New York

Robert Freidus Gallery Inc.
New York, New York

Preface © Copyright 1983 by Kenneth Donney All illustrations © Copyright 1983 by Robert W. Fichter

This book has been published to accompany the major retrospective exhibition, *Robert Fichter: Photography and Other Questions,* held at the International Museum of Photography at George Eastman House, Rochester, N.Y., between December 10, 1982 and February 27, 1983. The exhibition travels to Florida State University, Tallahassee, Florida, September 5–October 17, 1983; Frederick S. Wight Art Gallery, University of California at Los Angeles, December 13, 1983–January 15, 1984; Columbia College, Chicago, Illinois, April 1–June 30, 1984; San Francisco Museum of Modern Art, August 15–October 15, 1984; University of New Mexico Art Museum, November 3–December 16, 1984. The exhibition has been curated by Robert A. Sobieszek.

The exhibition has been generously assisted by the National Endowment for the Arts, a Federal Agency.

Additional assistance has been given by the New York State Council on the Arts.

Library of Congress Catalog No. 82-061524

ISBN 0-8263-0674-8

Design concept by Jack Nicholson, Tallahassee, Florida.
Design by Robert Meyer, Design, Inc., Rochester, New York.

CONTENTS

"The books are color comics. 'Jokes,'" Jim calls them. Some lost color process has been used to transfer three-dimensional holograms onto the curious tough translucent parchment-like material of the pages. You ache to look at these colors. Impossible reds, blues, sepias. Colors you can smell and taste and feel with your whole body. Children's books against a Bosch background; legends, fairy stories, stereotyped characters, surface motivations with a child's casual cruelty. What facts could have given rise to such legends?"

—William S. Burroughs
Cities of the Red Night, 1981

"Big Science. Hallelujah. Big Science. Yodellayheehoo."

—Laurie Anderson
"Big Science,"
ca. 1982

FEARLESS FICHTER AND THE ANTIHUMBUG MOVEMENT
by Kenneth Donney

George Orwell had no doubt about what distinguished his best writings from his worst:

". . . [I]t is invariably where I lacked a political purpose that I wrote lifeless books and was betrayed into purple passages, sentences without meaning, decorative adjectives and humbug generally."

This was the conclusion Orwell drew in the essay "Why I Write," a short work where he discussed his conscious attempt "to fuse political purpose and artistic purpose into one whole." He believed that courage is needed, along with talent, to successfully complete such a fusion.

What has all this to do with Robert Whitten Fichter? Well, Fichter *never* lacks political purpose, usually fuses that purpose into his nonpurple pictures, and always entertains us with his antihumbug specifically.

I once introduced Fichter (to an audience that was about to enjoy one of his inimitable slide lectures) by describing him as a truly unique individual, a visionary whose endearing sense of humor and eminent artistic talents are second only to his oxymoronic juxtapositions, with the emphasis on the "oxy." He may be a Cracker from Florida, but he's artfully seasoned.

Fichter sees. He sees the contradictions of the human condition and he helps us to see their resolution. Life against Death, Love against Hate, Intelligence against Stupidity, and Wisdom against Ignorance. And, above all, Justice and Health against Injustice and Sickness. The Florida Cracker cracks that whip!

Theory, if it's good, helps us to see far, clearly, and beneath the surface. Fichter is a theory-oriented artist in the tradition of Mark Twain, George Orwell, and Woody Guthrie. And all *we* have to do is look at Fichter's visions, his compelling visions. Visions that bring laughter and tears, visions that always entertain.

By depicting human folly, events representing apparent and bleak finishing points, Fichter simultaneously and implicitly provides us with challenging starting points. From these starting points, Fichter teasingly provokes us into creating our own future visions, the mirror-opposites to his. In this sense, all of his pictures are metaphorical double exposures. But what is being exposed?

Twain exposed the double-standard, Orwell the double-think, and Guthrie the double-cross. Fichter exposes the double-bind, that vicious circle of humbug surrounding you and me.

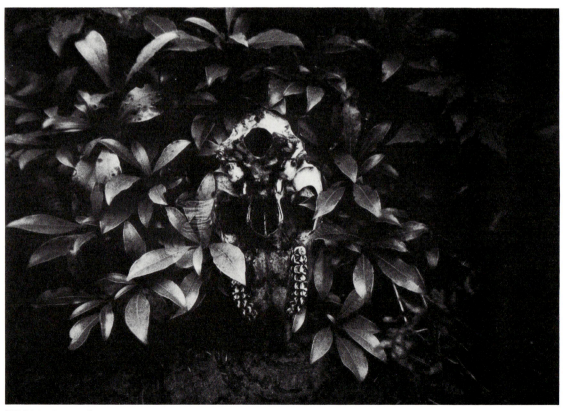

[SKULL IN FOLIAGE], ca. 1967
Collection of the artist (Cat. no. 33)

ENGAGING FICHTER

An Agrarian Gothic

Somewhere, a small herd of steers stands ruminating in a stream before an exceptionally lush, verdant landscape of foliage, palm trees, century plants, and waterfall. A nude woman sits on top of a rock pointing to a turtle half hidden in the ground beneath her. Another woman luxuriates under the falling water. At a distance, a man attends to some wild birds, perhaps guinea hens. Ignored by all, a ruined carcass of an automobile lies barely discernible in a young growth of palm fronds. (See illustration, page 18).

In various other places and landscapes, dogs sport multicolored wings, butterflies speak their minds, oak trees are terminated by girdling, and fish are lectured out of water. Artists' lay figures act out lessons wearing clay mule heads, a few rows of green onions constitute a garden, women sunbathe in suburban backyards, sectioned and labeled cows hover above vintage military tanks, and skeletons scream silently in rictus and often wear tennis shoes.

In these landscapes, peaceable kingdoms abound, perpetually assailed by combatting forces, and the Lone Cowboy of the Apocalypse oversees all the final possibilities of a humane art and fragile life (ill. p. 53).

Robert Whitten Fichter is, for all intents and purposes, that Lone Cowboy of the Apocalypse. His terrain is the post-industrial landscape, and some of the various flora and fauna that inhabit it have just been described. Like the mythic American figure of the cowboy or pioneering farmer, Fichter is wryly humorous in the face of adversity, a teller of incredible camp fire stories, blatantly idealistic, independently idiomatic and an agrarian fiercely zealous of the natural order of things not mucked up by man. These traits make up both his character and his very personal art.

He is a rambling American landscapist, although the range he looks out over and portrays in his pictures is most often visionary, having more to do with a narrative accretion of fabulist artifacts and composite ironies than with a strictly mechanical naturalism. His symbolic landscapes are much in the vein of Edward Hick's *Peaceable Kingdom*

and Albert Pinkham Ryder's *Death on a Pale Horse*. The big difference is that Fichter's contented kingdom is either on display in a butcher's vitrine or on the sidelines of aggression, and his figures of death gallop across shattered freeways (ill. pp. 48,51). To be sure, there are also passing references to Frederick Remington's violent frontier and even to Martin J. Heade's macroscopic celebrations of pure nature, but mostly his art is symbolist.

The America Fichter depicts in his drawings is really stylistically closer, when tightly controlled, to Saul Steinberg's and, when at its most spontaneous, to Robert Crumb's *Comix* than to most any other contemporary artist. His photographs, whether straight, contrived or montaged, share more of the sensibilities of Clarence John Laughlin, Jerry Uelsmann, and Robert Rauschenberg (in his assembled "Combines") than those of Ansel Adams or Eliot Porter. And his narrative poetics are most comfortably situated within the companies of John Berryman's *The Dream Songs*, Richard Brautigan's *Trout Fishing in America*, and William S. Burrough's *Cities of the Red Night*, with additional connections to James Agee, William Faulkner and Jack Kerouac.

All in all, a thoroughly modern American artist—one whose blend of aggressive idealism and naive immediacy could say with candor: "These photographs, drawings and writings are the acts of a desperate man, flawed and able to communicate less than a tenth of what he feels and imagines. I am a traditional American artist. I have constantly practiced to be able to perform without thought . . . to see the thing for all its implications . . . not to work toward a preset example . . . to try to move with the material both corporal and spiritual."[1] Fichter is a traditional American artist—a visionary "hard gore/core expressionist"[2]—a romantic spirit at odds with his own capacities and with the limits of his variously chosen techniques for expression and with a need to get it all out as fast as possible. It is not just the ruminating steers that are important, but also the implications of that ruined sports car—the man-made detritus in the garden.

A self-professed "third generation Florida Cracker," Robert Fichter was born in Fort Myers in 1939, but spent most of his early life in Sarasota. "I grew up in large part in Sarasota," he says, "amid the ruins of the depression destroyed landscape left by Ringling when his House of Cards failed. We used to roam about among the fake renaissance sculpture that one would find on [Lido Key]. So I grew up in a real scene that looked much [like] a lot of 18th century landscapes (Romantic Italian Ruins) that Europeans painted about Italy."[3] This vision of a ruin-romanticism, a fascination with the destroyed artifacts of civilization has continued to hold sway over the artist—a fascination nurtured by the emotions of a mournful nostalgia over what was once and a fearful trust that such past lessons are simply metaphors of an inevitable future. Much as Ozymandias mocked the false pride of lasting grandeur, Fichter's post-industrial landscapes also show that "Round the decay/ Of that colossal wreck, boundless and base/ The lone and level sands stretch far away."

Fichter's art may be romantically inclined toward black humor, fictive allegory, and even the grotesque. It is also an art that is manifestly adolescent in attitudes and demeanor, in style and tactics. In Gainesville, inland from the gulf, he learned photography in high school where, as art editor of the year book, he became in his words the "High School avant gardist," breaking rules and confounding expectations. The role was apparently comfortable and the strategy quite useful, adapted as it was from those feverish commitments entertained during the first blush of social and sexual consciousness and refined through the years. From the earliest "guerrilla" photographs to the later, more explicit series of "School Desk Drawings" (ill. p. 49), his art frequently exudes impatience, youthful rage and honesty, calculated deliberateness, and a sniggering, comedic approach to the themes of sex, death, war and destruction. These tactics have been maintained because they suit his impatient urge to tell it as he sees it and because they are so good at disarming and provoking.

At the University of Florida at Gainesville, Fichter's acute devotion to nature led him to biology and his good sense that man impinges on this nature turned him toward the study of anthropology. Around 1961, he and a group of student literati began a magazine entitled *Scope,* publishing such pieces as "Meditations on a Fallout Shelter" and social documentary articles on Spanish villages. Discovering Kenneth Patchen, Fichter developed at this time his view of what he calls the "Zen-proletarian artist"—socially committed, seeing things for all their implications, and speaking the language of every man. The comedy was really there for entertainment and a facile entry into subjects rather painful and serious—a politically charged comedic journalism.

Frustrated by what he could not say with words—although he is a brilliant, oral folk stylist—Fichter gravitated into painting and photography during his last years at Gainesville. During his first two years there, the Fine Arts department had stressed a non-objective and formalist style of art, a style not adaptable to Fichter's sensibilities. When, however, the emphasis of the studio arts faculty shifted more towards figuration and representation, he turned to a major in painting and printmaking. In this situation Fichter found his disparate interests and needs consolidated in two things: photography and the experience of studying it with Jerry N. Uelsmann. Uelsmann's intensely passionate and almost spiritual belief in a surreal poetics of the imagination, his blend of pictorial psychoanalysis and visual wit, and the imagistic liberalism inherent in his concepts of "post-visualization" and the "contrived image" were perfect for Fichter. Thematically, the two artists may, in their maturities, be quite different, but they share a commonality of attitude in terms of their sense of literal metaphor and surreal landscape visions more of the mind than fact. Uelsmann's dream vistas are fundamentally in stasis and atemporal; Fichter's are redolent with action and located precisely in the past, present or future.

Uelsmann was also instrumental in presenting Fichter with a vastly enlarged range of alternative photographic possibilities, historical and contemporary. What strikes us first about Fichter's early work is its darkly symbolic and hermetically

"Southern Gothic" quality. That cow skull absorbed within a twilighted foliage and the blurred, ghostly figure standing before a deteriorated wall, both from 1967 (ill. pp. viii, 9), are right out of Clarence John Laughlin or Ralph Eugene Meatyard. Meatyard's work from the early 1960s, especially those prints depicting sundry figures cavorting in and about abandoned buildings, or Laughlin's somnambulistic images such as *Elegy for Moss Land* (1940) or *Final Paradise for Dead Birds* (1951) find their reprises and echoes in Fichter's later work. All of these artists, including Uelsmann, are Southern fabulists or "phantasts,"[4] as are also Wynn Bullock and Frederick Sommer, two non-Southern influences on Fichter's imagery. All, too, mean for their pictures to provoke us into non-lineal thought and disturb our expectations of the world. "Art should be disturbing," says Laughlin, "it should make us both think *and* feel; it should infect the subconscious as well as the conscious mind; it should never allow complacency nor condone the *status quo*."[5] A better description of Fichter's work would be hard to find.

The "gothic" element in Southern art and culture is important in approaching Fichter. It is the image of the peaceable kingdom infiltrated by death and violence, the vernal pastoral sullied by deterioration and meanness. It is the Southern agrarian, the range cowboy, the self-styled naturalist, seeing his landscape as a theater of passion and noble faith bequeathed in trust, but threatened by the forces of "cunning, hoggery and callousness, brutal unscrupulousness and downright scoundrelism."[6] It is "The Southern Rose confused by Material Reality," as Fichter recently put it, with reality in the guise of an open-jawed alligator and the rose crying "Oh No, Bre' Rabbit, Oh No!"[7] Fichter's world, like those of Faulkner and Laughlin, teams with a barely submerged threat of violence. "But he smile, yes he do, he smile."[8] And he continues to use his wry, fantastic, humorous art to provoke and disturb us.

An Evident Process

Robert Fichter is primarily a pictorial artist, and his chosen medium is just about whatever material, instrument or process that can form an image. He has painted, drawn, photographed, etched, and lithographed, collaged and designed costumes. He has used acrylics, inks, dyes, emulsions, decals, rubber stamps, crayons, cloth, found images, and butterflies. His photographs have been shot and printed in a straightforward manner, multiply-exposed, sandwich-printed, hand-colored, solarized, cut and pasted, drawn and written on, and exposed on just about every photo-sensitive vehicle available. He has used Nikons, a U. S. Army Cloud camera, plastic "Diana" cameras, a Polaroid 20 x 24 inch view camera, duplicating machines, offset printing presses, and an airbrush. He has made gelatin-silver prints, cyanotypes (blueprints), lacquer transfer prints ("Henkelgrams," named after the technique's inventor James Henkel), gum-bichromate prints, Inko dye prints, Verifax transfers, Cibachrome and Polacolor prints, and photolithographs. The lists may not be exhaustive, but they should give an idea of the absolutely fecund character and energized nature of Fichter's work. As a draughtsman, he is sometimes tight and naturalistic but more often loose, caricaturish, and even cartoon-like. As a photographer, he sees himself "as L[eland] R[ice] said only yesterday/ A Photographer's Photographer/ Existing only on the tension within certain/ Over-trained minds/ Balancing on lines of meaning drawn from Historical Concepts/ of 'WHAT A PHOTOGRAPH SHOULD LOOK LIKE.'"[9]

What a photograph should look like has been one of the more central formal issues in Fichter's work. One thing is certain: a photograph need not look like what we expect. The photographic image, in its freest and most liberal sense, can be pushed, stretched, added to and subtracted from, augmented, and nearly destroyed. But it still remains photographic. Purist photography, as in the work of Edward Weston and Paul Strand, was not the only possibility; nor was the "straight," available light photography of Henri Cartier-Bresson or Robert Frank the only alternative. There were also collage, montage, multiple printings and exposures, and painted-on emulsions.

While still at Gainesville, Fichter encountered

the narrative, "contrived" structures of Uelsmann's photography, reinforced by the work of Laughlin, Meatyard, and Frederick Sommer. The "contrived" image—constructed, fabricated, staged, replete with personal and highly private mythologies, and readable on a number of levels—was appropriated by Fichter as much for its poetically discursive potentials as for its exceptional lack of formal restrictions and limits of action. In an unpublished essay, written around 1962 or 1963, Fichter saw the "contrived" image as very much a part of photographic modernism. "It is a raid on the inarticulate; it is an eye planted in mud in the bottom of a septic sink; it is and it isn't, no matter what Ansel Adams sez."[10] The tone and symbolism are strikingly similar to Max Ernst's definition of collage as "The simple hallucination, after Rimbaud; the placing under whiskey-marine, after Max Ernst. It is something like the alchemy of the visual image."[11] For the Surrealist Ernst, "whiskey-marine" was a "distortion, humorous and very serious at the same time." For Fichter, the chance of being comedic while disturbing and of playing with the limits of his art whle seriously questioning the sense and non-sense of the world was ideal.

In his "Notes on the Existence of Robert Forth," written also around 1962, Fichter seemingly paraphrases the photographer's notion of extreme liberalism in photography. "I print everything the negative will carry; dust, scratches, figure, image, muth [sic], philosophy: and that ain't all [,] there's some kind of vision here too: oh boy!"[12] This sort of open freedom is carried through so much of Fichter's work, an engagement with the exercise of artistic options encouraged by the photographers and other educators he most came into contact with during the late 1960s: Henry Holmes Smith, Nathan Lyons, and Robert Heinecken, among many others.

In graduate school at Indiana University, where Uelsmann also had attended, Fichter worked under Smith, a provoking Socratic, a garrulous and satiric teacher, and a positive cynic intent on communicating something of the seriousness of the photographer's moral responsibility and the absolute requisite that the artist use his intellect in addition to his eyes and camera. For Smith, the artist had first to "face squarely the embarrassments of the human predicament. No other medium is so open in its candor, so able to emphasize the peculiarly relevant detail, underline an essential vulgarity, make us aware of some shocking crudity."[13] Smith believed that the photograph, styled in the tradition of Bosch and Brueghel, could reveal what T. S. Eliot called " 'the boredom, the horror, and the glory' of human existence." Smith also stressed the camera's facility in dealing with dreams, metamorphoses, and fantasy. "Multiple exposure can be used . . . combining conventional camera and lens images in this way, however, involves . . . a neat balance between the rational and the irrational." Formally, Smith emphasized the very obvious idea—obvious at least today—that the photograph was both "*fact* (the image as witness)" and "*artifact* (the image as image)." From these points, Fichter went on to rationally play the game of locating the delimitations and mutability of his art while still retaining his "Zen-proletarian" concept of the artist. It would be wrong to judge Fichter's art as one of commitment—this has too much the overtones of social realism—it is rather an art of engagement: a moral involvement with the processes of thinking, looking, feeling, and making.

Fichter's MFA thesis was entitled *Notes from a Biological and Psychological Garden* (1966), and in it are the keys to the rest of his art. In the thesis statement, Fichter presents himself as a thoroughly Romantic artist, an artist as a visual poet, "motivated only by the images I can derive from a natural macroscopic/microscopic world; increased, decreased, multiplied, etc. etc. by my own vision to create a melodramatic image that can telegraph my psychological feeling toward the world."[14] He aligns himself with Van Gogh and Gauguin and with the New York Abstract Expressionists of the 1950s. "I do not undertake any image which does not have emotional meaning for me." The twin themes of biology and psychology are straight out of his earlier fascination with natural science and anthropology; and the garden is still a landscape.

"The implication of a Biological Garden is that

of a place where specimens are prepared for later study and by extension, that too would be the function of a Psychological Garden. Thus my imagery is drawn from a biological world and is developed only when I feel that the image has psychological relevance to my current feeling. This is best explained by saying that I am vastly interested in the biological world in an ecological sense, and that I am most interested in the themes and subthemes that it suggests to me: the place of man in the physical world as an interacting species with the most highly developed apprehension system. The forms that I select from the biological world create the reality of my work and become, through their melodramatic presentation, the psychological side of my work. The question of why I would use certain forms to create one image and other forms later in another image is the area to consider here, and so becomes psychogenic."

This psychogenic imperative to the formal choices of Fichter's craft is partly a function of an expressionistic impatience with capturing his mental images, and partly a result of the protean nature of his facility with picture making. This would explain the inclusion of etchings (intaglio prints), lithographs, and photographs (both straight and manipulated) in the thesis. In a most revealing statement, Fichter summarizes his attitude to the multifarious aspect of his art, a summary that still pertains. "To be honest all these prints look alike to me. It is the look of the blacks attempting to overwhelm the white light from within the image. It is only the surface feel that enables me to tell one method of production from another. They were all fixed from my mind. They [were] all fixed from the romantic, melodramatic battle of darkness against light." The latent threat of violence discernible in the Southern Gothic is here in open conflict. The metaphor of "darkness against light" is admittedly rather obvious and coy, but in the sense that it explains Fichter's self-perceived engagement with the forces of his art and his visions of melodrama, such a fundamental frankness is disarmingly charged; after all, out of darkness issued light and shortly thereafter the primal garden landscape.

Protean Technics

"Some times I'm in a mo zay ic mood, and sometimes I'm in a single frame mood. Sometimes I'm good and sometimes I'm terrible. Artists don't have to stay in 1 (one), singular mood all the time. Look at Paul Klee andhislineonawalk. Watch that line."[15]

Among Fichter's various strategies in art, perhaps the most difficult to assess at first review is the manifold and diverse nature of his pictures. Yet his multivarious images are precisely his genius, if you will, and the basis for both his underground reputation in the photographic community and the tremendous success he has had with students. When what you have to say can be said in whatever way available to you, at least the first step toward expression is facilitated. Of course, few can be as visually prolix as Fichter, but their options have been made certainly more numerous by his example. Fichter has become something of an educational cult figure, a rambling, itinerant carpetbagger of pictures and of lessons on how to visually communicate "our hopes, fears, daydreams, nightmares."[16]

The mandate for teaching his art came from his formal mentors in a natural, academic way, but it was also a product of his association with the artist and photographic educator Nathan Lyons, with whom he worked for two years at the George Eastman House Museum in Rochester, New York. Here, between 1966 and 1968, Fichter was exposed to the wealth of photographic history in the museum's collections, thus furthering his store of visual information. It was here too that he came in contact with other, Northern makers of "contrived" or manipulated images such as Thomas F. Barrow and Alice Andrews (now Alisa Wells), as well as other photographers like Harold Jones and Roger Mertin. I first met the artist at the middle of his stay in Upstate New York, at that point when the formal and experimental options of his art were about to expand at an incredible rate. Lyons might have left Fichter with the notion that "a photographer's work should be consistent within itself,"[17] but Fichter fully realized that within this statement was still the germ of utter material free-

dom. Consistency did not mean the same physical look throughout a work, nor did it necessarily dictate the same mood. "Mo zay ic" or "single frame," it was the vision and the spirit that counted.

In Rochester during the late 1960s, Fichter's imagery revolved about his restless travels and the premises of what a gelatin-silver print could look like and still be photographic. An absolutely commonplace vernacular and everyday subject-matter constituted the arena for this investigation. In a fashion not unlike Robert Frank's, Fichter documented the transitory American landscape from the moving cockpit, to extend his metaphor, of his Dodge van. Chain gangs alongside the highway, shimmering Airstream trailers, and trucks with melancholic horses staring out—all that grabbed his sensibility and ironic fancy was recorded, for the most part straightforwardly, but often augmented by darkroom technics. A solarized or fogged cloud hovers over the horse and a simple lawn chair spiritistically shares the trailer's space (ill. pp. 24,25).

Real and fictive landscapes expand and contract. Panoramas of highway, subtly solarized, are not too different from widened visions constructed of multiple television images. And more daringly, suburban or small-town urban backyard pastorals are fabricated by running the same roll of film a number of times through a toy-like "Diana" camera (ill. pp. 16,17). The snapshot pastoral is vaguely, yet materially present; just enough has been encoded to see the sunbathing woman, her blanket and chairs: a primary landscape image, reduced to a grainy, gritty, light-streaked, and blurred token of semblance and ritualized photographic essence. Fichter's concerns with what fundamentally makes a photograph photographic and what really determines photographic information continued with other processes during the next decade, most notably in his ultimate deconstructions, *This Picture Spot Recommended* (cyanotype, 1969; ill. p. 32) and *Photo Info #2* (Inko dye print, 1973; ill. pp. 42-43). In each of these prints, there is an overall array of brushed-on, light-sensitive strokes, each stroke containing the barest minimum of photo-graphic detail. The sense is totally non-photographic. If anything the intent is to produce a "tachist" work, in both the sense of the immediate, gestural marking of a surface as in Abstract Expressionism; and of a moral spot or blemish bringing into question the ethics and limits of photography's truth-telling function.

Fichter is most adroit and quick in absorbing various picture making techniques and processes; as Gainesville photographer Evon Streetman puts it, "he goes through them like Kleenex."[18] He had gained a facility with antiquated printing processes in graduate school, where he and others were encouraged to experiment with 19th century techniques. Betty Hahn, a student at Indiana with Fichter, was to become by the late 1960s a model for his use of gum-bichromate. At UCLA, where he taught from 1968 to 1972 and again in 1976, Fichter was affected by a broad spectrum of aesthetics and attitudes, all having to do with alternative possibilities to the traditional silver print. Todd Walker's solarized and sensuously pearlescent nudes; Walker's use of Ferro-prussiate emulsions (cyanotype or blue-printing) and his simplified technique of gum-bichromate printing; and Robert Heinecken's politically assaultive combination prints, use of ink transfers and offset lithography, and his compositional work of this period—all of these found fertile ground in Fichter's art.

Heinecken's "agitprop" aesthetic—the densely, double printed pages of text and images in his sexually loaded *Mansmag* of 1969 or his antimilitaristic *Periodical #5* of 1971 and even his early (1963) found image transparency of a child shooting a rifle and entitled *Child Guidance Toys*—this combatively political aesthetic is similar in method and look to Fichter's *Florida Bomb Sites* (ill. pp. 36-37) from the series *The Dream of Perpetual War* of 1971 and his other Verifax transfer prints from the late 1960s and early 1970s. The compositional structure of one discrete image balanced above a second and possibly multiple image, a structure so frequent in Fichter's gum-bichromate and cyanotype work of the seventies, derives ultimately from Robert Rauschenberg's large and impacted, constructivist painting of the previous

decade, and may even have additional parallels with Mark Rothko's painterly schemas (ill. pp. 45, 57). It is also reinforced by Heinecken's *Fourteen or Fifteen Buffalo Ladies* series of 1969.

Heinecken and Walker were at one point using commercially available, undeveloped rolls of erotic negatives and incorporating the developed images in their pictures, thereby aestheticizing an artless and rudely sexual iconography. In his matchless fashion as Southern naturalist, Fichter photographed a provocatively posed nude with a blatantly distorting wide-angle lens and embedded the chesty "lady" in a primary colored field of Inko dye with the image of an alligator in a second field, and entitled the work *Lady with Gators* (ill. p. 41). Another Southern "rose" threatened by "material reality"? After all, regardless of the trips he made to teach and work at Franconia College in New Hampshire, Columbia College and the School of the Art Institute in Chicago, and in spite of the numerous workshops he conducted, he has continued to be on the faculty of Florida State University in Tallahassee since 1972. His is still the "shuffle-footed, backwoods, Southern attitude," as Evon Streetman describes, but one that is "so very urbane at the same time."[19]

The realism, as well as the speed and efficiency of the photographic process is central to Fichter's art. On one of his drawings, there is the statement: "Cast all objects and negatives [and] positives together—if I past[e] them all together to get a third object, then this is a logical outgrowth of my use of photograms and negative positive photo information."[20] The logical outgrowth of his formal experimentation with the photographic print as a fabricated and manipulated object came to a natural conclusion. He had, by the late 'seventies, tried nearly everything and had done almost anything to the photograph. By that time, too, there was a natural consolidation or distillation of his thematic priorities. Much of what he wished to say about the process of photography had been said; much of what he still had to say could only be stated visually by drawing or a direct photographic confrontation with nature on the one hand and by the recording of assembled, still life

scenics modeled from his fertile imagination and mordantly cynical fantasy on the other.

Since around 1978 and 1979, his paintings on paper have become progressively impasto laden and "energistically" broad, and his drawings more and more narratively coherent instead of visually surreal alchemistries of collage. Fichter's photographs, likewise, have lately been terribly precise and perfectly rendered: either the most direct and traditional black and white prints or startlingly brilliant Cibachrome color prints. Or else, they are those luxuriantly saturated and overwhelming Polacolor photographs on the scale of 20 by 24 inches, which Eileen Cowin calls "sooo beautiful they will knock your socks off."[21]

Consolidating The Horrific

Robert Fichter's pictorial work is essentially one of political realism couched in private mythology. His pictures "face squarely the embarrassments of the human predicament," as Henry Holmes Smith put it and as Fichter sees that predicament. But the horrors of civilization are so overwhelmingly prevalent and awesome that a mythopoetic system and a comedic, ironic posture are the only sane ways of approaching these realities over a period of time. In a drawing done in the late 1970s, Fichter sketched himself saying "I made photos about every atrocity committed by mankind but every body just laughed. So I took to drawing.... Want to see a butterfly assassination?"[22] His landscapes are, to be sure, filled with butterfly assassinations and more: war, devastation, littering, militarism, pollution, over-industrialization, over-mechanization, land abuse, and thermonuclear holocaust. The intent is to shock and disturb, if not to action at least to realization.

Behind the final, black humor aside and visually parenthetical gesture, the artist grins in near rictus through the horror. As John Berryman's Henry says, "Mr Bones, we all brutes & fools."[23] Like Daumier, Thomas Nast, and Victor Gillam—earlier geniuses at depicting social ills in a palatable and entertaining way—Fichter frequently charms and seduces us by the humor, wit, and absurd fantasy of his envisioned world. Once we

have entered that world, however, we realize how really frightening are its implications. And once we encounter the salient details of the landscape, we quickly apprehend the more mordantly bleak spirits of such artistic antecedents as Jacques Callot, Goya, and James Ensor.

Some Southern country singers manage to begin with light or humorous lyrics only to have those lyrics turn dark and treacherous once the listener has been absorbed. Willie Nelson's classic "I Just Can't Let You Say Goodbye" and the songs of Gamble Rogers, a Floridian like Fichter, come to mind. The fictive folk character, "Still Bill," who appears in some of Rogers's monologues and songs, is reportedly based on the Tallahassee farmer, Bill Blakey, a close personal friend of Fichter's also, and the source of Fichter's image of the lonesome cowboy. Both Blakey and "Still Bill" are Southern philosopher-farmers, charming you with down-home humor into listening to their dire tales. With Fichter, it is the precise blending of humor and the horrific that both triggers and engenders his art—a fantastic theater of the grotesque achieved through satire, caricature, and cynical distortions.[24]

Fichter has characterized his more recent drawings and photographs as exercises of a "psychotic, narrative attitude."[25] If there is any question of insanity with his work, it is on the order of the alienated clarity and idiosyncratic idealism displayed in the visions of William Blake. Blake's staged tableaus of various figures enacting scenes before either desolate or bucolic vistas bear some resemblance to Fichter's still life narratives set against fabulist landscapes. Instead of the winged Elohim creating Adam, however, we are presented with a winged dog rising over flowers (ill. p. 14); in place of Adam and Eve finding the body of Abel, Fichter has *Baby Gene Pool Finds Bones Asleep on the Sands of Time* (not illustrated); and in lieu of Blake's River of Life with Christ and two infants swimming through the stream of time, Fichter gives us polluted waterways surrounded by the garbage of modern civilization and the only thing swimming is the skeleton of a fish (ill. p. 59). Fichter might be, as he states, "interested in the bizarre, the insane, the nefarious, the restless, the absurd;"[26] but his interest appears most rational in the face of those topics he has chosen to focus on.

The imagery of conflict and war have been perennial issues in Fichter's work since the first, in part stemming from childhood drawings of military aircraft, but undoubtedly given abject immediacy by the real life grotesquerie of Vietnam and its attendant atrocities. In the rebus-like collage, *Deep Sea Diver With Amazing Eye for Butterfly* of 1968 (ill. p. 30), a serene marinescape lies just beneath combatting infantry. "A New Photograph of a Successful Weapon of War," derived from a vintage photograph, is used in an extended series of gum-bichromate and cyanotype prints, as are two other World War I images of soldiers examining weapons and dead bodies (ill. pp. 45-46). *The Dream of Perpetual War* series of Verifax prints dates from 1971, and the *War Memorial* group of cyanotype prints from 1975 (ill. p. 48). Drawings from the late seventies are replete with fighter aircraft, tanks, and cannon as well as provocative nudes and hostile phalluses. Toy soldiers and Chinese toy tanks are recurrent themes in the late color work; and a lone soldier strides across a blasted landscape painting, *War Without End* (1981) (ill. p. 56). The forces of aggression and violence are ubiquitous.

In Fichter's "battlefield" landscapes, whether drawn or depicted in large color photographs, the conflict takes many forms: generic war, localized action and U. S. involvement in El Salvador, injustice in Mexico and Florida, and a universalized ruination of natural resources through pollution and abuse. There is a reason why Fichter has made the oil can a major icon or, at times, significant detail in his imagery: it is both a primary emblem of mechanized society and a symbol of our contamination of nature (ill. pp. 68,69). A similar rationale leads him to document the ravages done to ecosystems and woodlands of the South in his recent *Damaged Nature* series of straight, black and white photographs (ill. p. 80) and color. Those straight rows of pines have been neatly planted and cultivated by the lumber industry; unfortunately, with the oaks and other food-bearing plants

cleared out, no other life is sustained in these forests. And if these mundane horrors are not enough, there is, by the way, still the potential, terminal horror of them all: thermonuclear devastation.

A veritable menagerie of private "critters" assist in animating Fichter's confrontations with the horrors he sees. As early as 1962-1963, he had already described the significance mythopoetic symbolism held for him. "The task of the modern photographer," he wrote, "working with the Contrived image is to see symbols that offer meaning and meanings over a greater span of aesthetic so that the image gets to the viewer's gut before he can turn away."[27] He likened the photographer's potential for such mythologizing to the primitive artist who combines parts of nature to fashion a new reality, like the centaur fashioned from man and horse. It should not, therefore, be surprising to find winged dogs or anthropomorphic mules in Fichter's scenic narratives.

Sometimes, these characters are emblems of pure, unassuming nature, while sometimes they are transparent alter-egos fabricated for psychological survival. The dog is one such creature, mutely observing the action or staring back at us and the artist. Comic like Thurber's dogs and expressionistic like Gauguin's, Fichter's dog is more likely the lone cowboy's constant sidekick, a token of nature faithful to man, "Hero the One Spot Dog," and a watchful device pointing out where the threat may be (ill. pp. 23,39,47). Mr. Bass is more complex. He is a familiar Florida animal, he can be the mythical carp of the orient invested with magical powers, or he can be the product of a befouled nature while escaping his polluted waters to gain oxygen. Mr. Bass can be aggressive if he wills, swallowing little Jonah or the fleshless remains of Everyman prostrated before big business; or he can be vulnerable, as in his guise as the "Fish-Out-of-Water," to such things as lectures on what death is all about. He is the symbol of survival in the face of adversity, telling us in one drawing that "the one that lives is the one that gets to tell the tale!" (ill. pp. 52,75,76).

A vision as terrible and so beyond conception as a total nuclear holocaust and the apocalyptic landscape that will be left in its wake demands some highly adaptable dramatic actors. Mr. Bones, a skeletal metaphor for Everyman dancing a post-nuclear Dance of Death by himself or with Ms. Bones, is perfect. What better spokesman to resurrect than one so mediaeval for the future dark ages? Fichter's Mr. Bones tells the Fish-Out-of-Water what death is like (ill. p. 50) and lectures to Baby Gene Pool about the night before the holocaust (not illustrated). Baby Gene Pool is a survivor, a mute survivor like Mr. Bass. With a cyclopean eye and in diapers, he gets the news about the 19th century whaling industry (another Fish-Out-of-Water of sorts) (ill. p. 74) and eventually finds Mr. Bones's remains in the desert wasteland. Like Mr. Bones and the Mutant Mule who surveys the *Dismal Swamp* (ill. p. 82), Baby Gene Pool is comedic, derived as he is from a character in Z. Mosley's "Smilin' Jack" cartoon strip and the figure of the Michelin Man, and a definite product of blackened humor. All of these figures are reliefs from the unthinkable. Henry, the narrator of John Berryman's *The Dream Songs,* and himself a fashioner of another Mr. Bones, defined the situation succinctly: "Man has undertaken the top job of all,/ son fin. Good luck."[28] Fichter's Mr. Bones, with a catfish in his hydrocephalic skull, gives the situation an understandable simile: "It's just like life flashing before your eyes" (ill. p. 53).

Epilogue

As with Blake, there are distinct forces of good and evil in Fichter's visionary art, forces that are, if not biblically conceived at least sacredly inspired from the promises of the past and the dismal realities of the present. But future options are not as clearly given in the work as are future possibilities. A pair of drawings, done in Los Angeles in 1976 with Niji pens and watercolor washes, juxtapose the divergent polarities of "Then" and "Now." *Now* is a predictably distressful and gruesome analogue to present problems. *Then* is a perfect arcadian idyl, with mythic, half-animal and half-human figures luxuriating in primal nature. A pile of "Cezannesque," geometric volumes, intelligently made and artful, blends deli-

cately in with the background surroundings (ill. pp. 58,59).

Fichter is uncertain, however, to just what "then" his image refers. It could be the then of Genesis or of a sylvan, pagan antiquity; but it might also refer to the then of the future, as in "it will then come to pass." Nonetheless, it is the ideal, universalized paradise that can still be envisioned if not materially realized. It signifies that concord so elusive in the post-industrial landscape, and discernible only in the corners of small domestic gardens with their slight edging of ironic green onions or wistful Gerber posies colorfully set against a darkly mysterious background. In Fichter's art there is a tension between positive and negative just as there is one between the terrifying and the humorous. Flowers in full bloom vie for photographic attention with deathly skulls in foliage. Ghostly blurred figures against Southern Gothic walls sometimes give way to the sensuously promising and nonthreatening Kimono-Clad-Person or Princess. The dismal swamp has not as yet overtaken all the Southern gardens (ill. pp. 54,84).

Robert Whitten Fichter is the "photographer in the post-industrial landscape" as pictured in his etching of the same name (ill. p. 71). He is at the very edge of a surreal and absurd universe, peopled with figures of Gina Lollobrigida bathing in a pool, Steve Reeves attempting to overturn an elephant, and a putto flying near a shattered remnant of a freeway overpass. The completely ludicrous gestures and icons that overwhelm the scene are incidental to Fichter's real engagement. The fantasy draws us in smiling, only to eventually discover the photographer at the extreme left edge, documenting a Goyaesque firing squad assassinating a group of ordinary people.

At other times and without camera or pencil, Fichter is the Lone Cowboy of the Apocalypse, watching the questionable activity of the Born Again Art Ass, paintbrush in mouth and palette on saddle, as it goes on its mindless way painting a religious picture which was in turn created by Fichter (ill. p. 53). Around both of them are grouped all of Fichter's "critters" and fictive alteregos, and in the background—always salient in

Fichter's art—looms the dark mushroom cloud and intense thermal wave of the final end. Nearby and ever watchful, that wonderful and loveable dog of Fichter's takes it all in.

NOTES

Except for minor punctuations all quotations taken from the correspondence and drawings of the artist have been left with their original spellings and word usages.

1. R. W. Fichter (hereafter RWF), cited in exhibition announcement, Camerawork Inc., 1978, unpaged.

2. RWF, letter to N. Lyons, 3 February 1966.

3. RWF, letter to R. A. Sobieszek, undated (26 February 1982).

4. Cf. J. Williams, "Three American Phantasts: Bullock, Sommer, and Laughlin," *Aperture*, IX, 3 (1961), unpaged.

5. C. J. Laughlin, "A Statement by the Photographer," in *Clarence John Laughlin: The Personal Eye*, Millerton (NY), 1973, pp. 13-14.

6. W. J. Cash, *The Mind of the South*, N.Y., 1941, cited in R. H. King, *A Southern Renaissance*, N.Y., 1980, p. 161.

7. RWF, letter to R. A. Sobieszek, undated (1982).

8. RWF, letter to N. Lyons and A. Andrews, 16 November 1965.

9. RWF, letter to J. N. Uelsmann, undated (1971).

10. RWF, "The Contrived Image in Modern Photography . . .," unpublished undergraduate essay, undated (ca. 1962), p. 1, courtesy J. N. Uelsmann.

11. M. Ernst, *Beyond Painting*, N.Y., 1948, p. 12.

12. RWF, "Notes on the Existence of Robert Forth," unpublished essay, undated (ca. 1962), unpaged, courtesy J. N. Uelsmann.

13. H. H. Smith, "Photography in Our Time: A Note on Some Prospects for the Seventh Decade," in *Three Photographers*, Kalamazoo (IN), 1961, unpaged, the following two citations are also from this source.

14. RWF, "Thesis Statement," unpublished essay, Indiana University, 1966, p. 1, the following three citations are also from this source.

15. RWF, *Confessions of a Silver Addic!* [sic], compiled and duplicated pages from sketchbooks, no place cited (Covington, KY), n.d. (1979) unpaged.

16. RWF, *Confessions of a Silver Addic!*, cited.

17. Cited in RWF, artist's statement, in *Into the 70's*, Akron (OH), 1970, 44.

18. E. Streetman, conversation with R. A. Sobieszek, 29 May 1982.

19. E. Streetman, cited.

20. RWF, statement on undated drawing in the artist's collection.

21. E. Cowin, "On Robert Fichter," *Working Papers*, 3 (May 1982), p. 14.

22. Reproduced in RWF, *Know Where to Look!*, Chicago, undated (ca. 1977), unpaged.

23. J. Berryman, "62nd Dream Song," in *The Dream Songs*, N.Y., 1981, p. 69.

24. Cf. W. Kayser, *The Grotesque in Art and Literature*, N.Y., 1966, pp. 173 ff.

25. RWF, from a tape of an undated lecture in Los Angeles (ca. 1981), courtesy the artist.

26. RWF, cited in exhibition announcement, Light Gallery, 1973, unpaged.

27. RWF, "The Contrived Image in Modern Photography . . .," cited, pp. 1-2.

28. J. Berryman, "46th Dream Song," in *The Dream Songs*, cited, p. 50.

ACKNOWLEDGEMENTS

No exhibition or book springs forth from any one impulse nor is either possible without the generous assistance of many individuals. The inspiration for the project "Robert Fichter: Photography and Other Questions" came primarily from my personal desire to see the artist's work to date assembled and thereby come to terms with its overall force and excitement. Fichter's work had seemed too important and much too vital to remain scattered across the country and inaccessible to a greater audience. Janet Borden, then of Robert Freidus Gallery, and Nathan Lyons of the Visual Studies Workshop, enthusiastically supported the idea of both exhibition and book from the very onset. Robert A. Mayer, Director of the International Museum of Photography at George Eastman House, was unflagging in his efforts to realize the entire project and is to be specially thanked for his continuous faith in it. Robert Freidus helped immeasureably in achieving the publication of this book.

Special thanks are owed to a great many people. For lengthy discussions about Fichter's work over a number of years and for critical comments on the book's manuscript, Thomas F. Barrow was invaluable as usual. For an incredibly energetic and provocative, night-long discourse about the artist and his work, Harold Jones and Todd Walker are to be fondly thanked, as are Kenneth Donney for his vibrant approach to Fichter's vision and Evon Streetman for patiently reviewing my tentative incursions into the Southern sensibility. Thanks are due to others who also shared their ideas and memories of Fichter: William Blakey, Peter Bunnell, Jo Ann Callis, Eileen Cowin, Darryl Curran, Marianne Fulton, Betty Hahn, Robert Heinecken, Roger Mertin, Virgil Mirano, Jack Nichelson, Nancy Smith-Fichter, and Jerry Uelsmann.

Very special thanks are also due to the staff of the Visual Studies Workshop, most particularly Helen Brunner and Joanne Ross.

Much appreciation is also extended to those staff members of the International Museum of Photography at George Eastman House without whose spirited assistance the project would not have been possible. Bonnie Ford and Boo Poulin of the Department of Photographic Collections are most especially thanked for their help in organizing and preparing the project and for their on-going commentary. Ann McCabe, Registrar, was instrumental in maintaining an efficient organization throughout the project's duration. Joan Pedzich and David Wooters assisted in the Archives; Barbara Puorro Galasso and Linda McCausland made the reproduction of Fichter's work possible; Grant Romer oversaw the necessary conservation of the larger and more fragile works; and Rick Hock and Carolyn Zaft were responsible for the exhibition's design and installation and were assisted by Seymour Nusbaum and his staff. Christine Hawrylak and Susan Kramarsky are gratefully thanked for their help in promoting the entire project. Andrew Eskind and Daniel Meyers are owed appreciation for all their administrative assistance, as is Jane Weller for her cheerful and daily help in the office.

Finally, my wife, Sonja Flavin, is most gratefully thanked for stoically learning to live with the particular visions of Robert Fichter and for sustaining with good humor the necessary intrusions of this project onto her life, even to the point of having a very special week surrounded by many of Fichter's "critters."

–R.A.S.

LIST OF LENDERS

The Art Museum, Princeton University, Princeton, NJ
Mr. & Mrs. Thomas F. Barrow, Albuquerque, NM
Eileen Cowin, Venice, CA
Robert W. Fichter & Nancy Smith-Fichter, Tallahassee, FL
Betty Hahn & Daniel Andrews, Albuquerque, NM
Robert Heinecken, Culver City, CA & Chicago, IL
International Museum of Photography at George Eastman
 House, Rochester, NY
Harold Jones, Tucson, AZ
Roger Mertin, Rochester, NY
Virgil Mirano, Venice, CA
Photo Archive of Colorado Mountain College at
 Breckenridge, Breckenridge, CO
Private Collection
Jerry N. Uelsmann, Gainesville, FL
Visual Studies Workshop, Rochester, NY
Todd Walker, Tucson, AZ
Alisa Wells, Santa Fe, NM

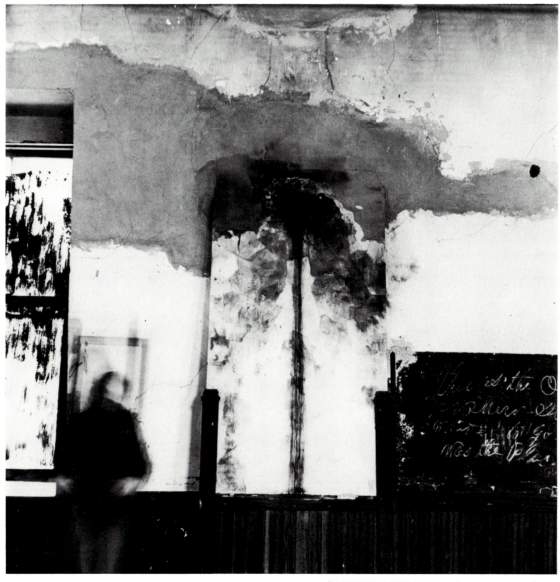

[FIGURE IN FRONT OF WALL (SELF-PORTRAIT ?)], 1967
Collection of Aliśa Wells on permanent loan to
Visual Studies Workshop, Rochester, NY (Cat. no. 24)

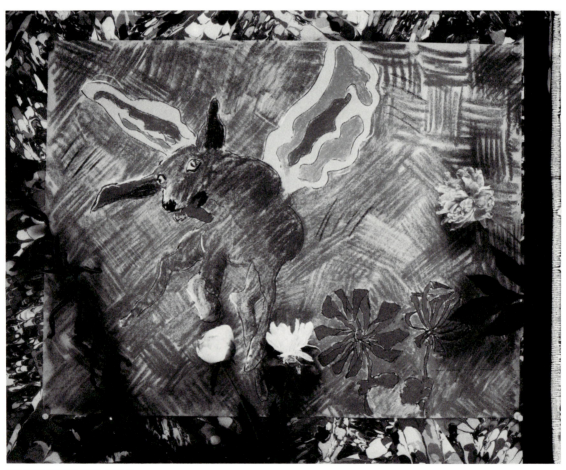

WINGED FLYING DOG, 1979-80
Collection of the artist (Cat. no. 131)

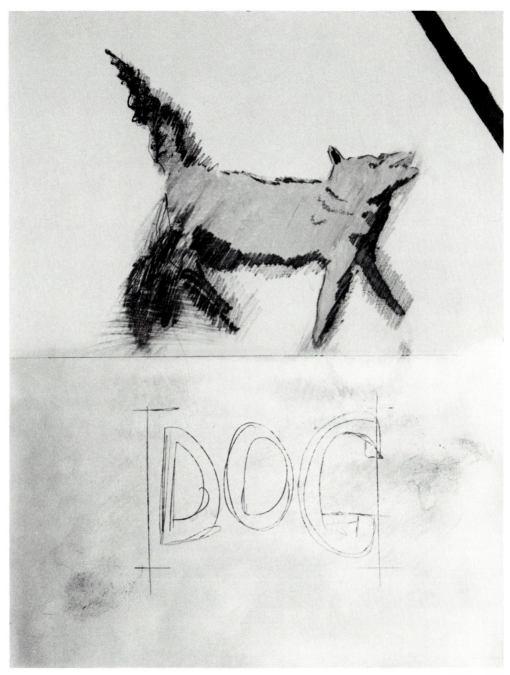

DOG, ca. 1967
Collection of the artist (Cat. no. 27)

[FEMALE FIGURE AND LAWN CHAIRS], ca. 1966-67
Collection of Aliśa Wells on permanent loan to
Visual Studies Workshop, Rochester, NY (Cat. no. 12)

[FEMALE FIGURE AND SELF-PORTRAIT], ca. 1966-67
Collection of Aliśa Wells on permanent loan to
Visual Studies Workshop, Rochester, NY (Cat. no. 13)

[FEMALE FIGURE AND SHOES], ca. 1966-67
Collection of Aliśa Wells on permanent loan to
Visual Studies Workshop, Rochester, NY (Cat. no. 14)

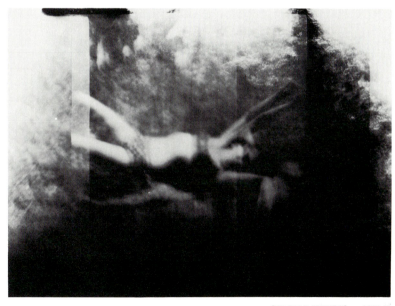

[FEMALE FIGURE], ca. 1966-67
Collection of Aliśa Wells on permanent loan to
Visual Studies Workshop, Rochester, NY (Cat. no. 11)

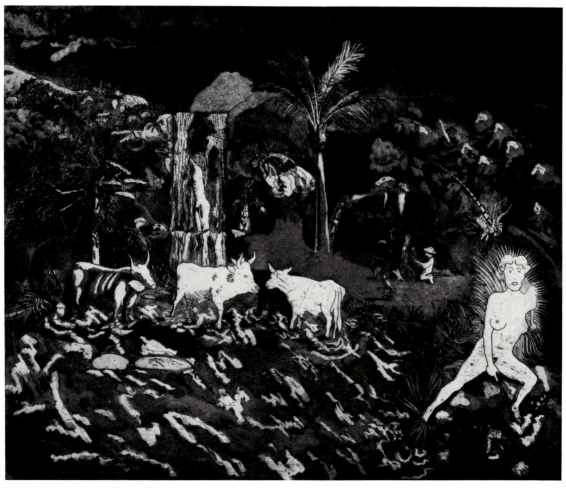

[COWS IN LANDSCAPE], 1976
Collection of the artist (Cat. no. 107)

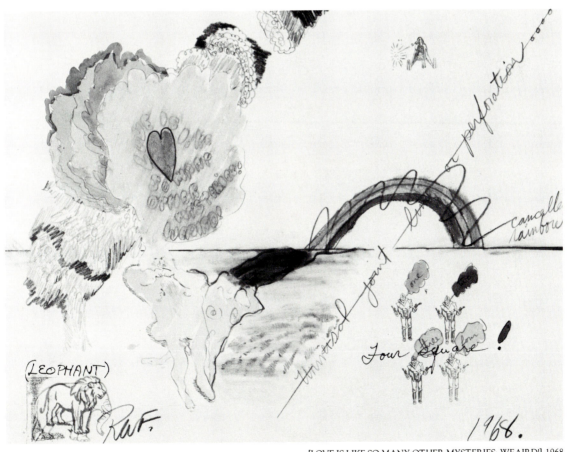

[LOVE IS LIKE SO MANY OTHER MYSTERIES: WEAIRD!], 1968
Private Collection (Cat. no. 38)

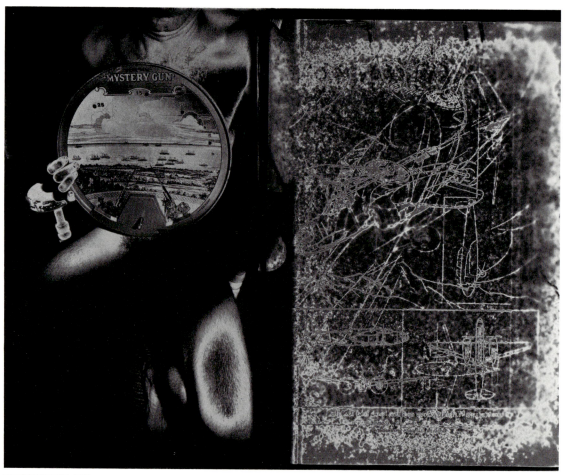

MYSTERY GUN, 1973
Collection of the artist (Cat. no. 85)

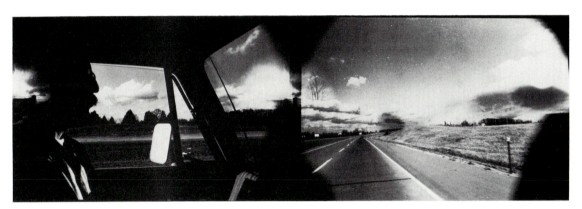

[DRIVER AND ROAD], 1967
Collection of the artist (Cat. no. 21)

["DEAR ALICE . . ."], 1970
Collection of Aliśa Wells on permanent loan to
Visual Studies Workshop, Rochester, NY (Cat. no. 60)

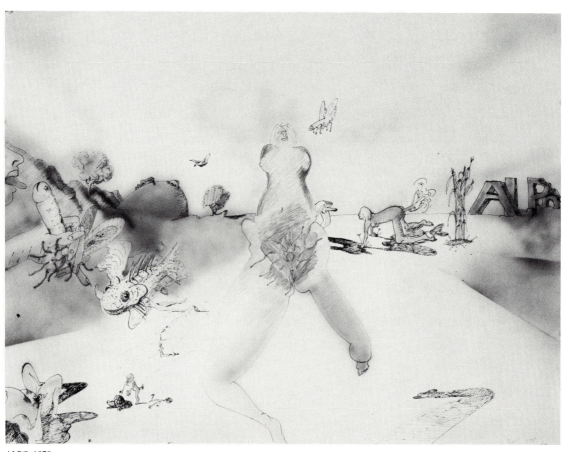

ALPO, 1978
Collection of the artist (Cat. no. 115)

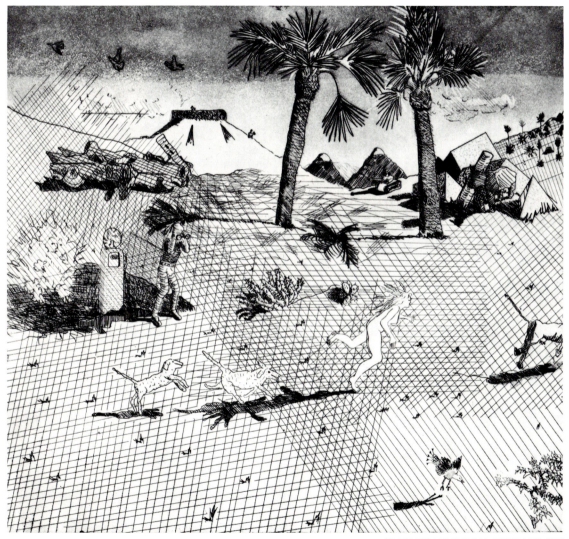

[FIGURES RUNNING IN LANDSCAPE], 1977
Collection of the artist (Cat. no. 114)

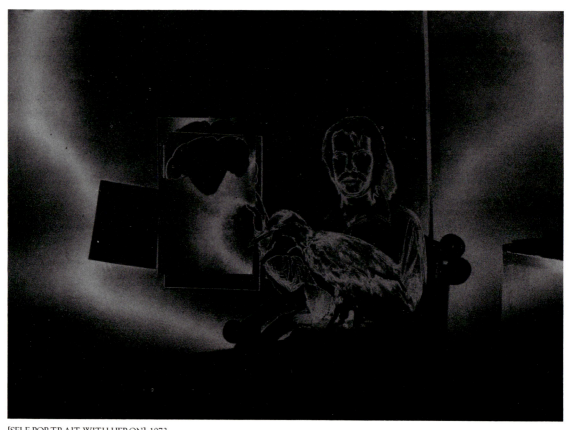

[SELF-PORTRAIT WITH HERON], 1973
Collection of the artist (Cat. no. 89)

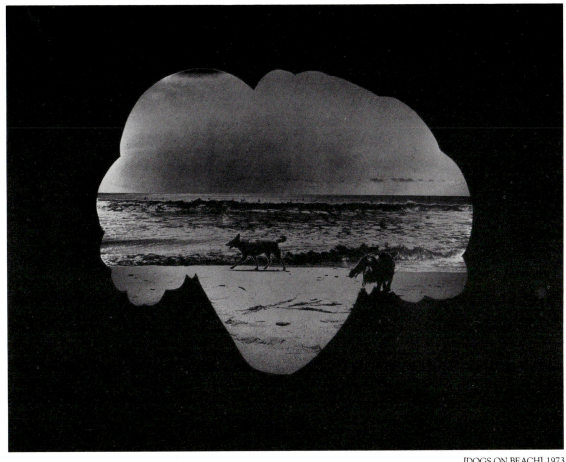

[DOGS ON BEACH], 1973
Collection of the artist (Cat. no. 81)

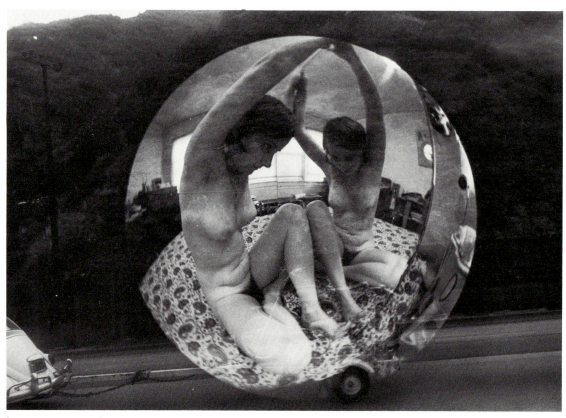

[NUDE AND TRAILER], ca. 1967
Collection of Roger Mertin, Rochester, NY (Cat. no. 32)

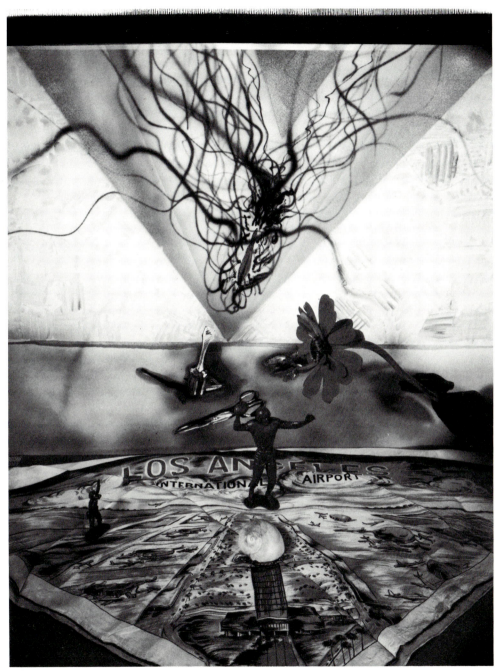

LAX SCARF PIECE, 1979-80
Collection of the artist (Cat. no. 130)

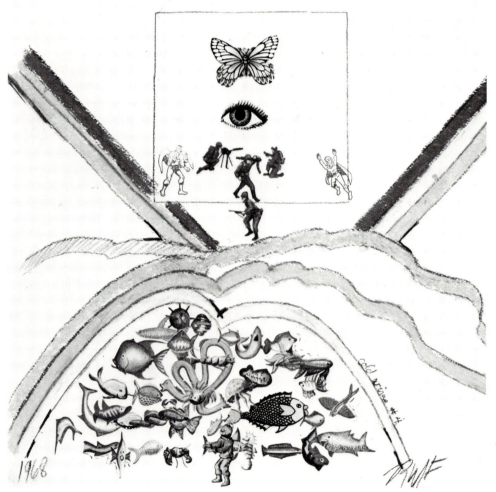

DEEP SEA DIVER WITH AMAZING EYE FOR BUTTERFLY, 1968
Collection of Mr. and Mrs. Thomas F. Barrow,
Albuquerque, NM (Cat. no. 36)

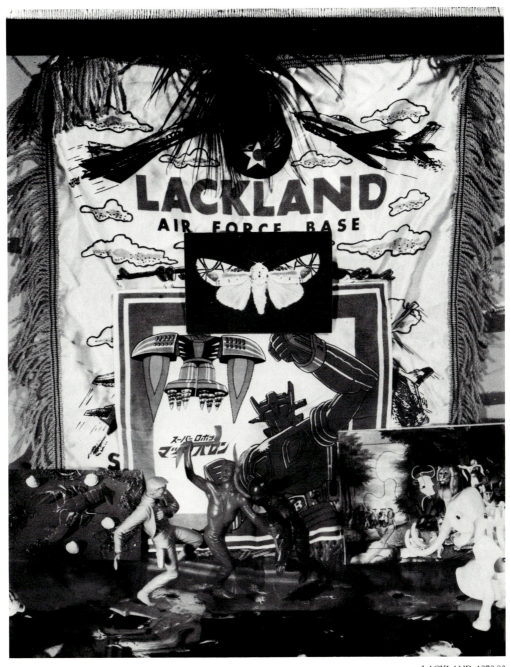

LACKLAND, 1979-80
Collection of the artist (Cat. no. 129)

RwK "The Picture Taking Spot Recommended..." 1969.

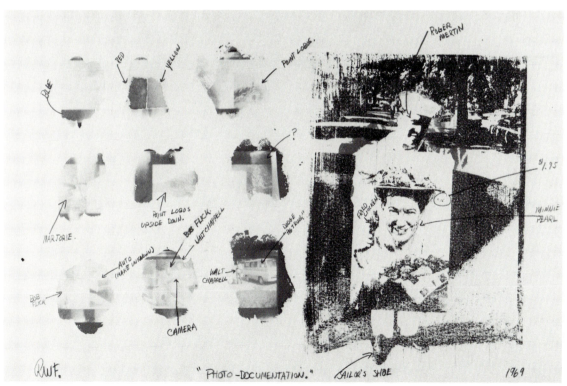

(Left)
THIS PICTURE SPOT RECOMMENDED, 1969
Collection of the artist (Cat. no. 55)

PHOTO-DOCUMENTATION, 1969
Collection of Roger Mertin, Rochester, NY (Cat. no. 53)

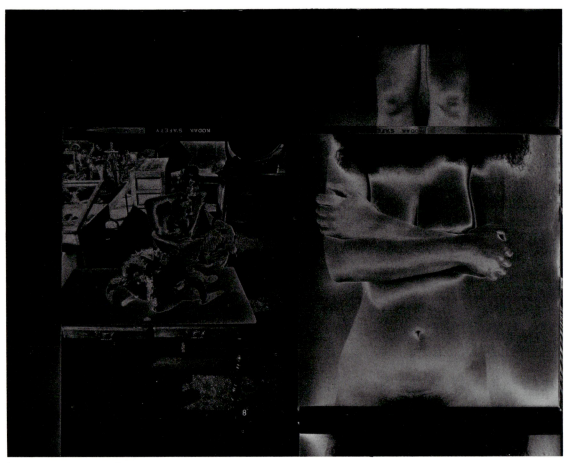

[RAM'S HEAD AND NUDE], 1975
Collection of the artist (Cat. no. 102)

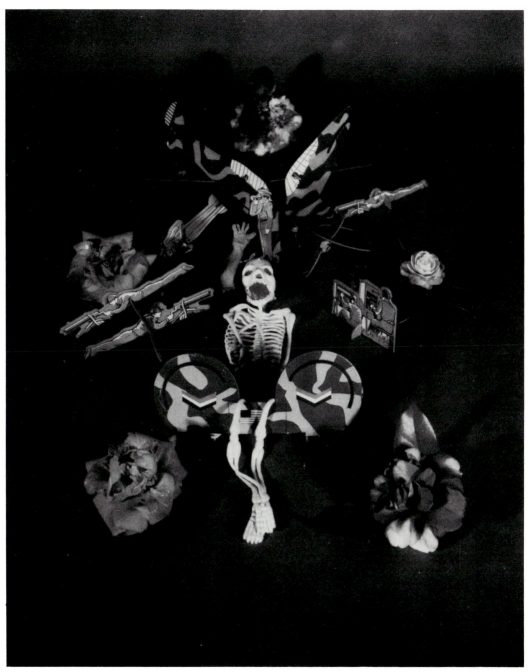

MIGHT MAKES NIGHT MANDALA, 1981
Collection of the artist (Cat. no. 170)

(Overleaf)
FLORIDA BOMB SITES, 1971
Collection of the artist (Cat. no. 75)

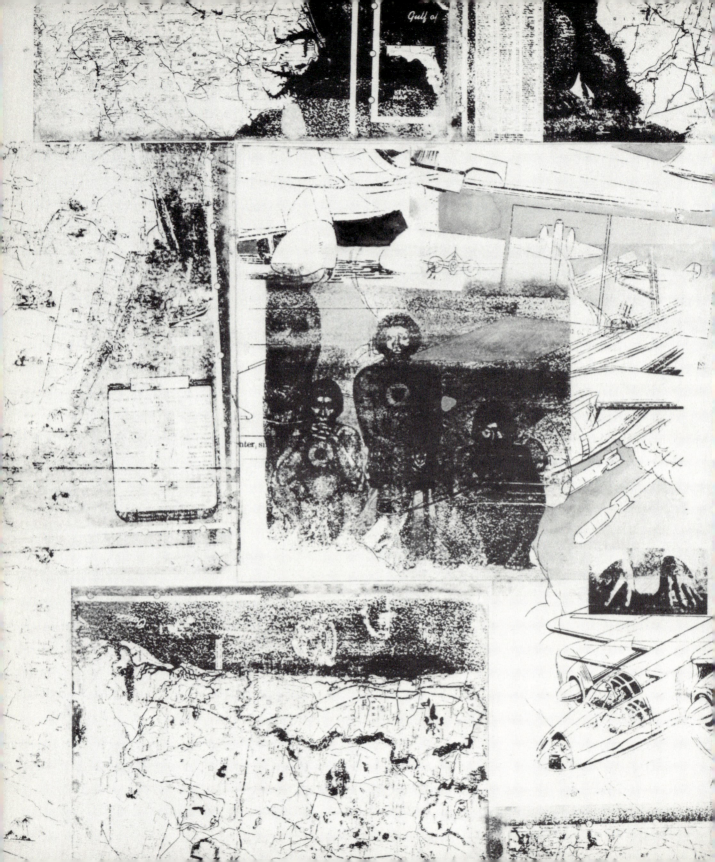

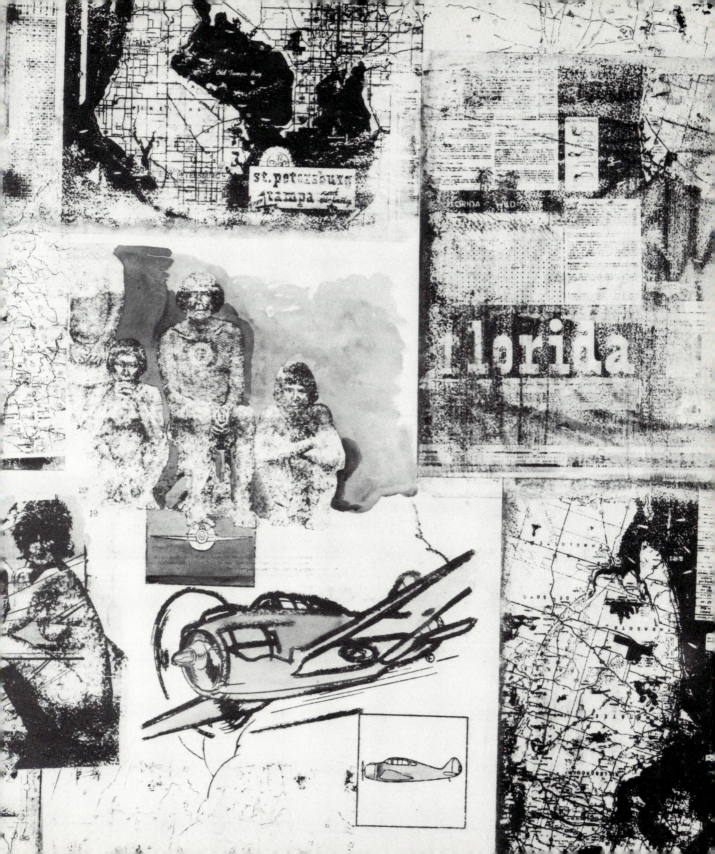

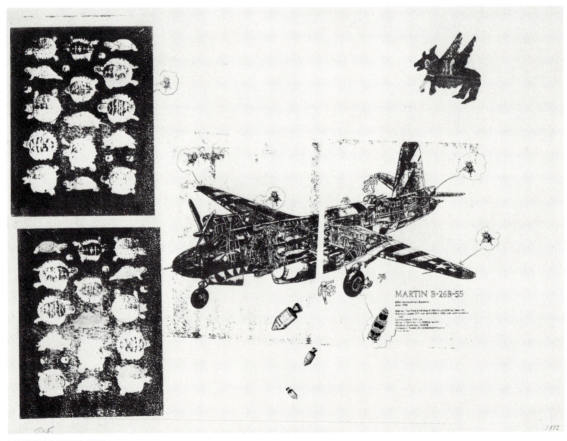

MARTIN B-26B-55, 1973
Collection of the artist (Cat. no. 84)

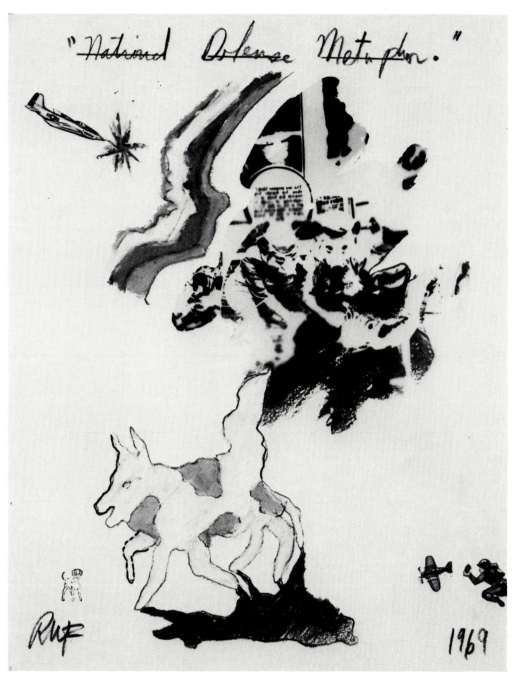

NATIONAL DEFENSE METAPHOR, 1969
International Museum of Photography at
George Eastman House Collection (Cat. no. 50)

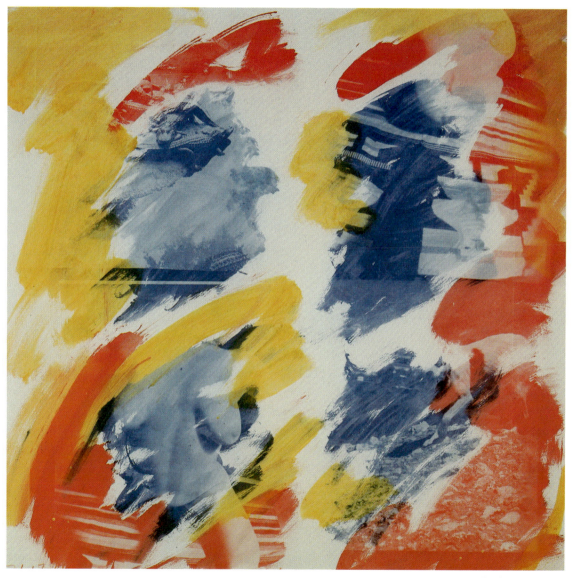

LADY WITH GATORS, 1973
Collection of the artist (Cat. no. 83)

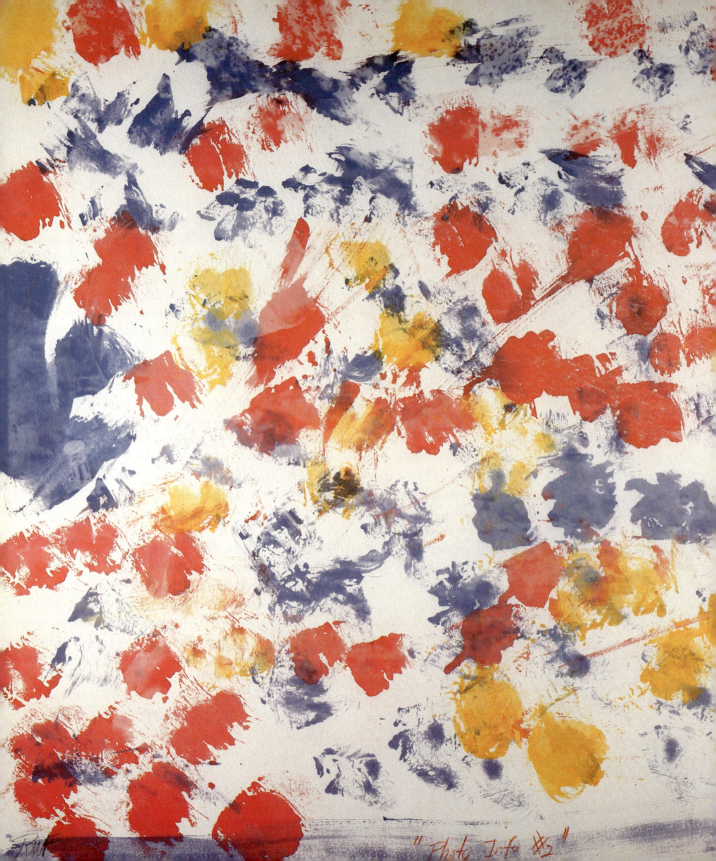

"Photo Info #3"

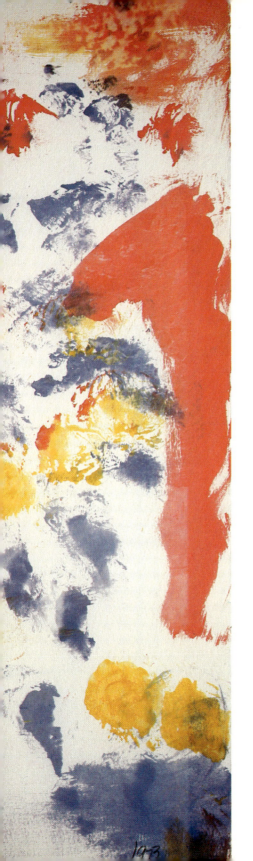

PHOTO INFO #2, 1973
Collection of the artist (Cat. no. 88)

[WARNING/DON'T FEED THE ALLIGATORS/FLORIDA], 1973
Collection of the artist (Cat. no. 93)

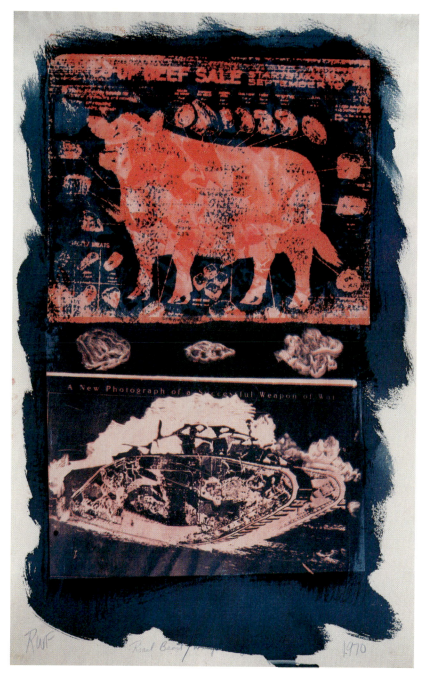

ROAST BEAST/WEAPON OF WAR, 1970
Collection of the artist (Cat. no. 64)

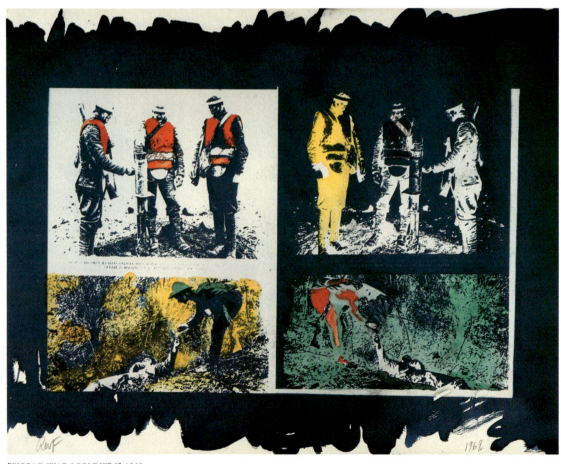

[WORLD WAR I SOLDIERS], 1969
Collection of Jerry N. Uelsmann, Gainesville, FL (Cat. no. 56)

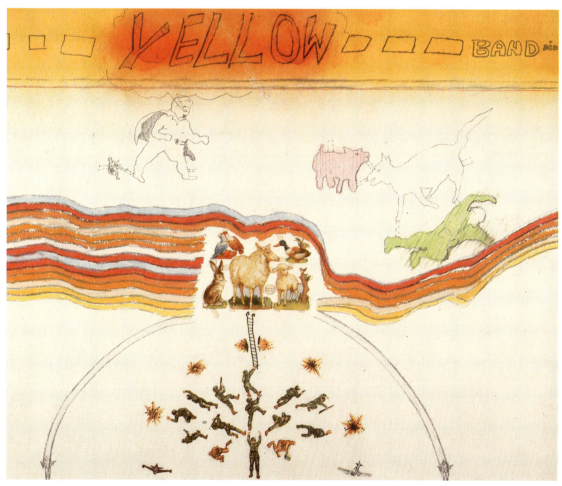

YELLOW BAND AID, 1968
Collection of Mr. and Mrs. Thomas F. Barrow,
Albuquerque, NM (Cat. no. 44)

SOLDIER'S DELIGHT, 1975
Collection of the artist (Cat. no. 103)

PEACE IN THE KINGDOM, 1975
Collection of the artist (Cat. no. 100)

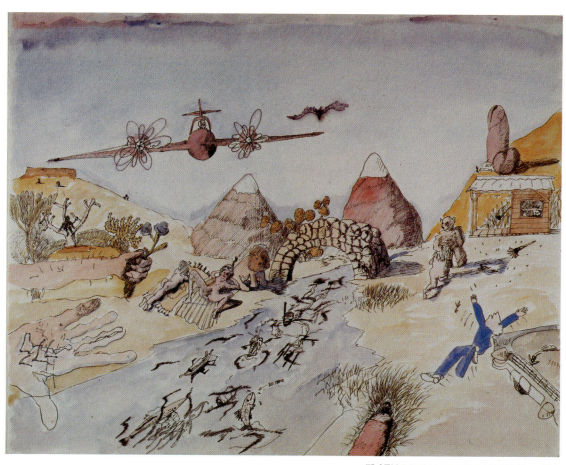

EROTIC LANDSCAPE WITH FIGHTER, ca. 1976
Collection of the artist (Cat. no. 111)

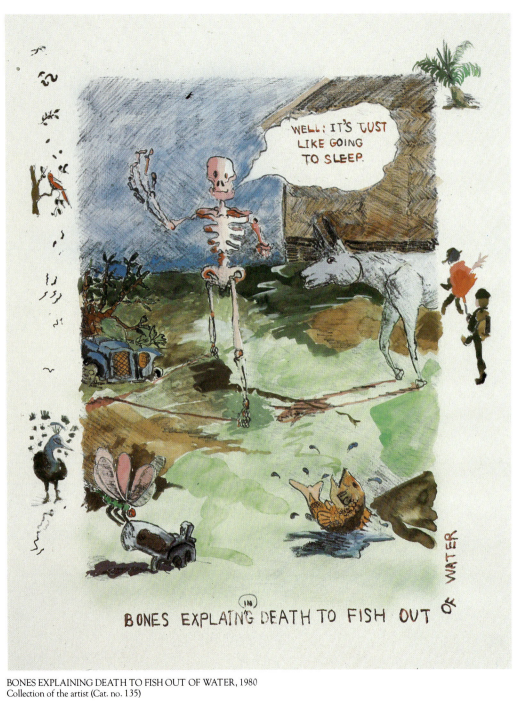

BONES EXPLAINING DEATH TO FISH OUT OF WATER, 1980
Collection of the artist (Cat. no. 135)

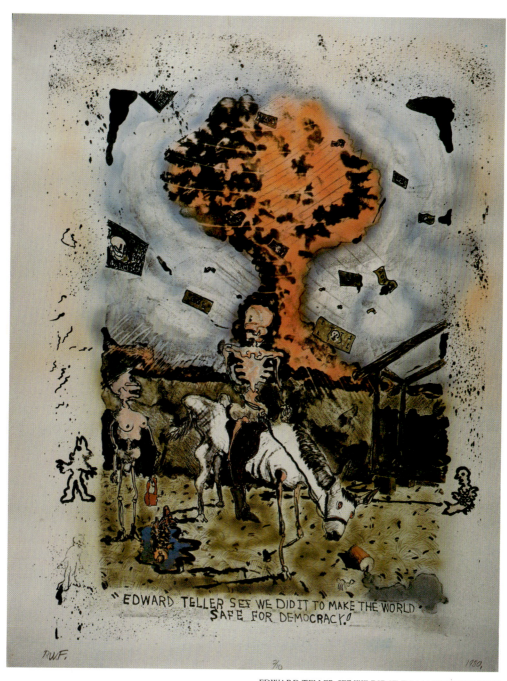

EDWARD TELLER SEZ WE DID IT TO MAKE THE WORLD
SAFE FOR DEMOCRACY!, 1980
Collection of the artist (Cat. no. 142)

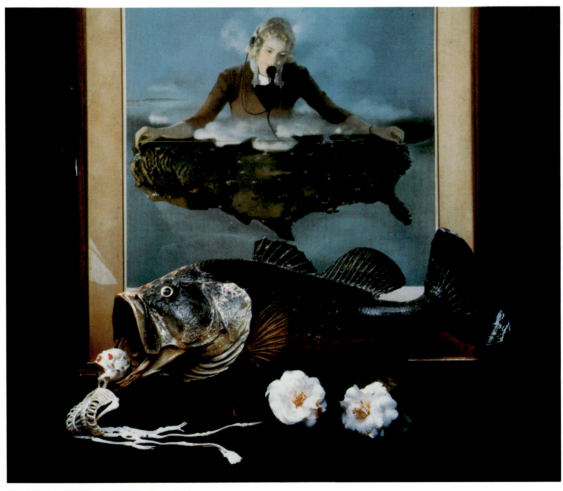

MA BELL MADONNA WITH MR. BASS, 1982
Collection of the artist (Cat. no. 179)

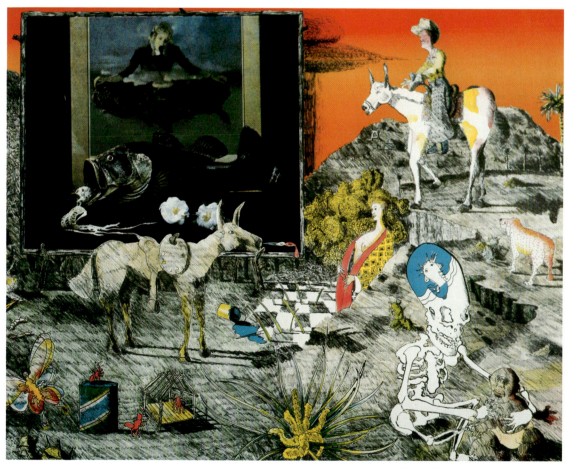

BONES SEZ TO BABY GENE POOL "IT'S JUST LIKE
LIFE FLASHING BEFORE YOUR EYES," 1982
Collection of the artist (Cat. no. 176)

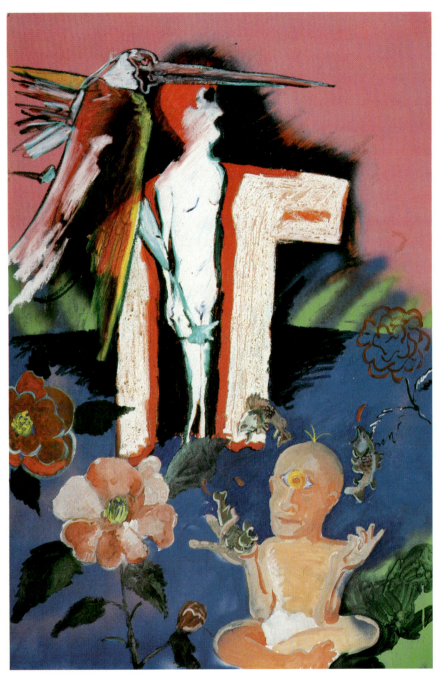

NIGHT CROWN HERON–BABY GENE POOL STUDIES
FISHERIES, 1981
Collection of the artist (Cat. no. 173)

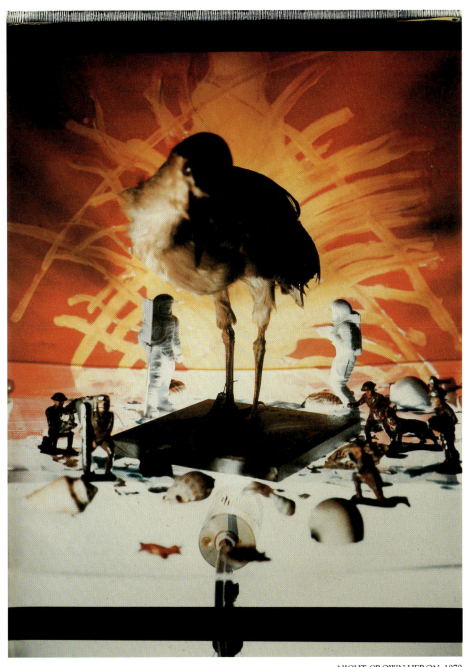

NIGHT CROWN HERON, 1979
The Polaroid Collection, Cambridge, MA (Cat. no. 125)

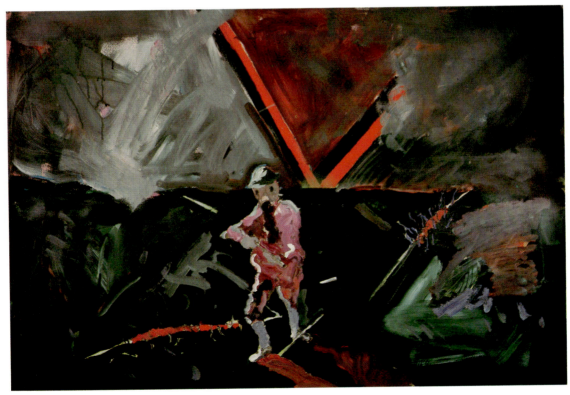

WAR WITHOUT END, 1981
Collection of the artist (Cat. no. 175)

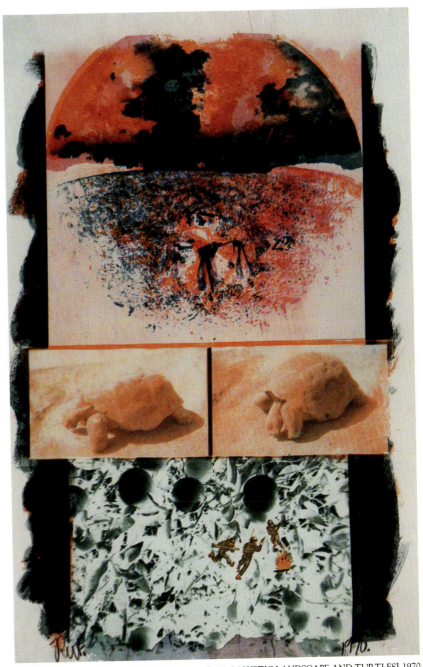

[APOCALYPTIC LANDSCAPE AND TURTLES], 1970
Collection of the artist (Cat. no. 59)

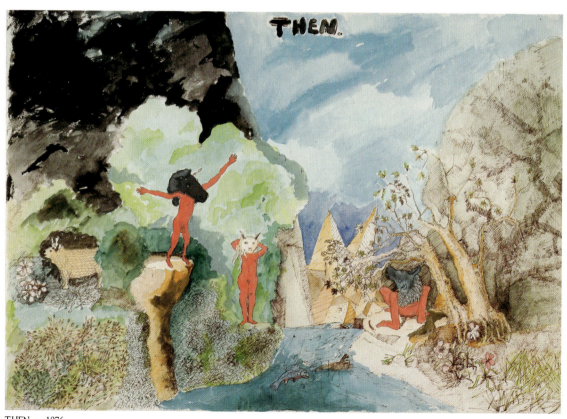

THEN, ca. 1976
Collection of the artist (Cat. no. 113)

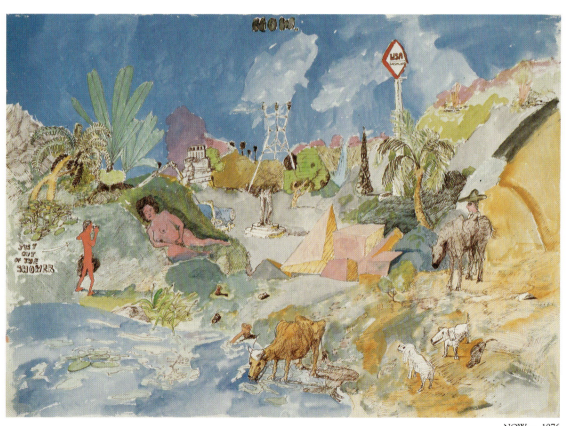

NOW, ca. 1976
Collection of the artist (Cat. no. 112)

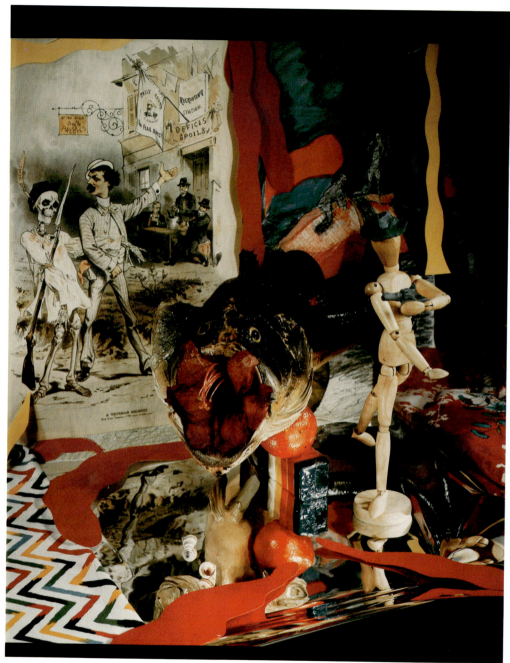

VETERAN RECRUIT #3, 1980
Collection of the artist (Cat. no. 153)

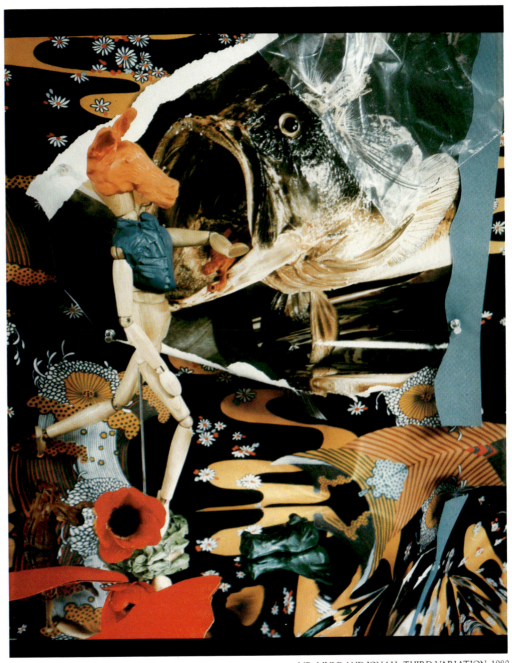

MR. MULE AND JONAH—THIRD VARIATION, 1980
Collection of the artist (Cat. no. 149)

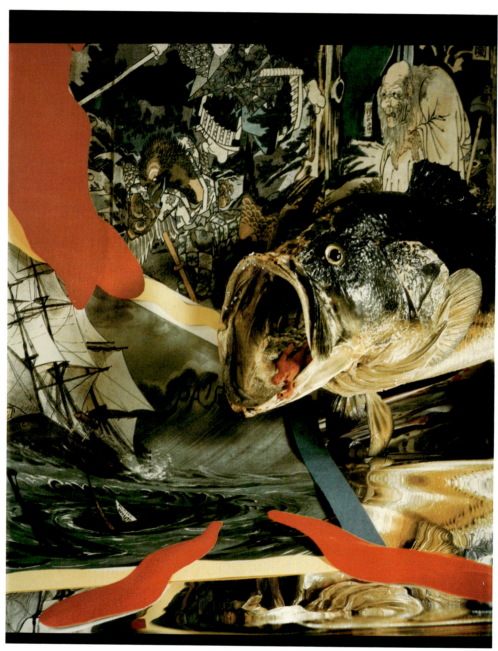

JONAH, 1980
Collection of the artist (Cat. no. 148)

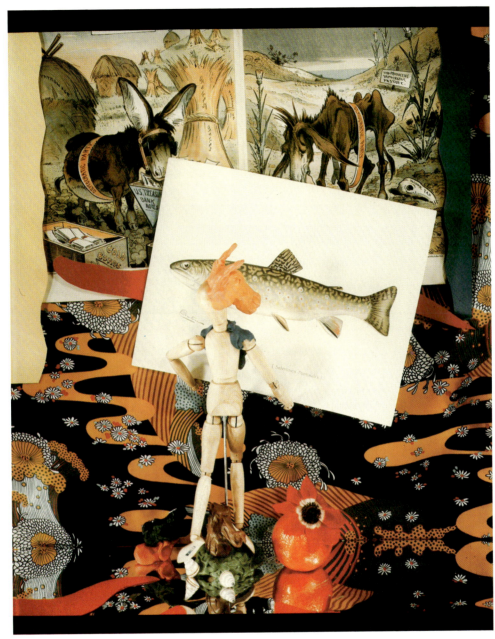

MR. MULE PRESENTS A TROUT, 1980
Photo Archive of Colorado Mountain College
at Breckenridge, Breckenridge, CO (Cat. no. 150)

NUDE WITH BASS, 1980
Collection of the artist (Cat. no. 151)

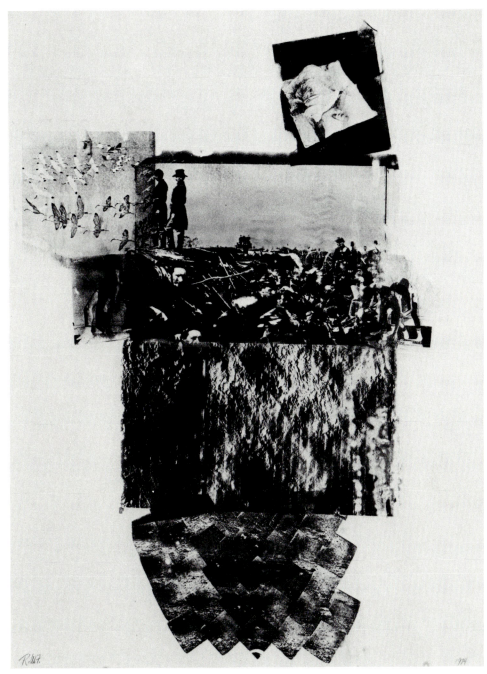

[CIVIL WAR SOLDIERS AND MOONSCAPE], 1974
Collection of the artist (Cat. no. 95)

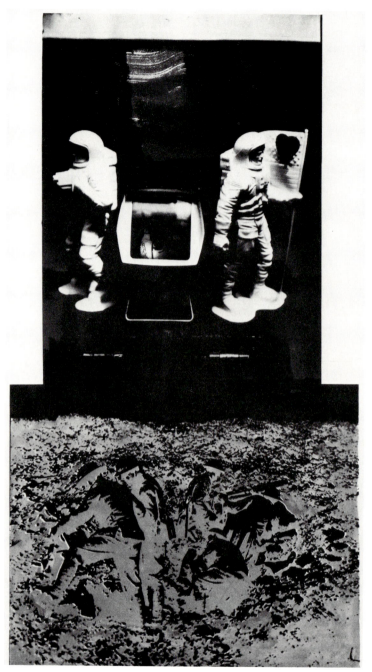

[ASTRONAUTS AND WORLD WAR I SOLDIERS], ca. 1970
International Museum of Photography at
George Eastman House Collection (Cat. no. 69)

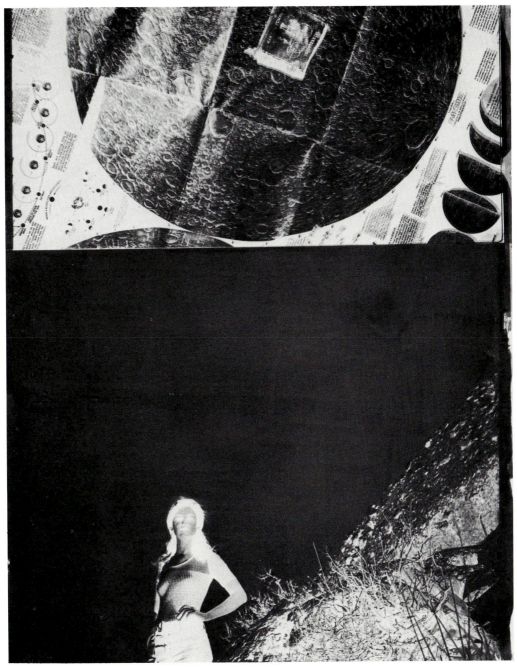

[NEGATIVE FIGURE AND MOONSCAPE], 1971
Collection of the artist (Cat. no. 79)

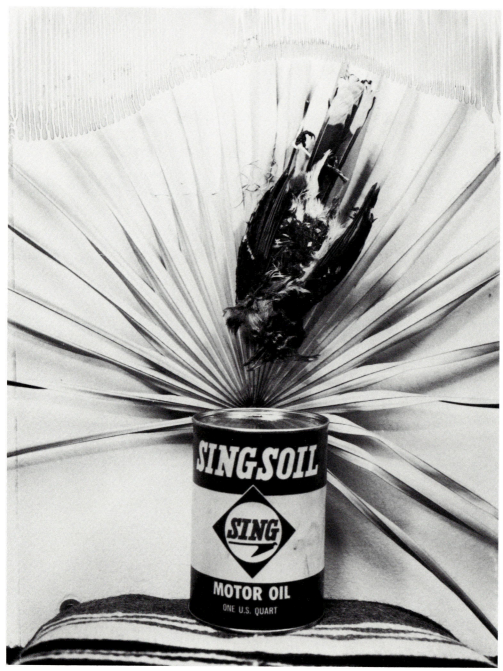

SING SOIL, ca. 1978
Collection of the artist (Cat. no. 117)

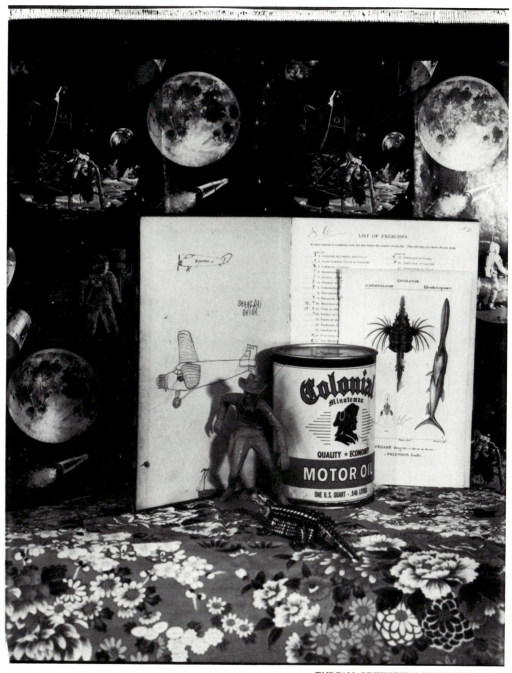

THE FALL OF WESTERN CIVILIZATION, 1979
Collection of the artist (Cat. no. 122)

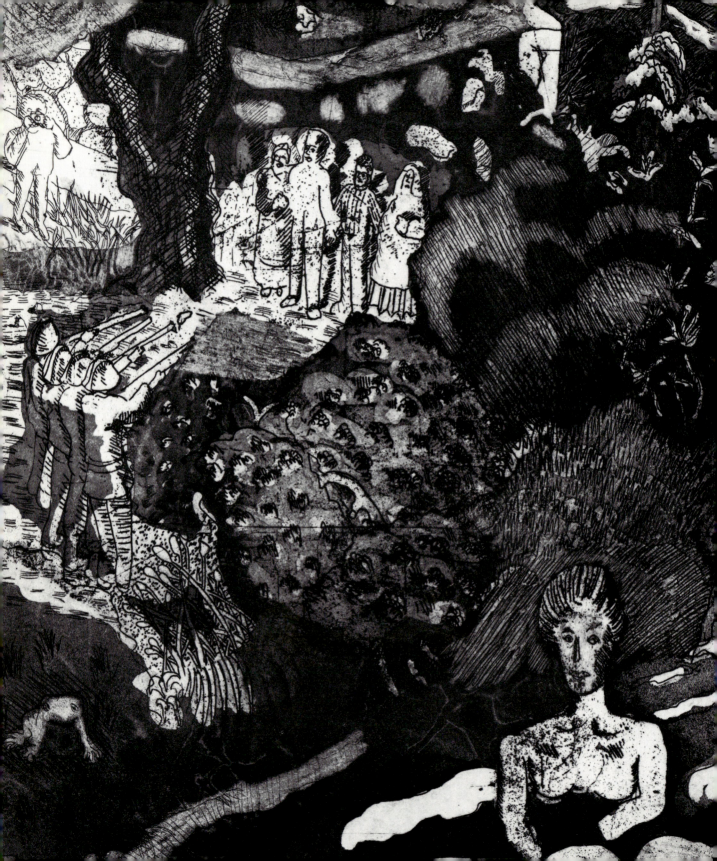

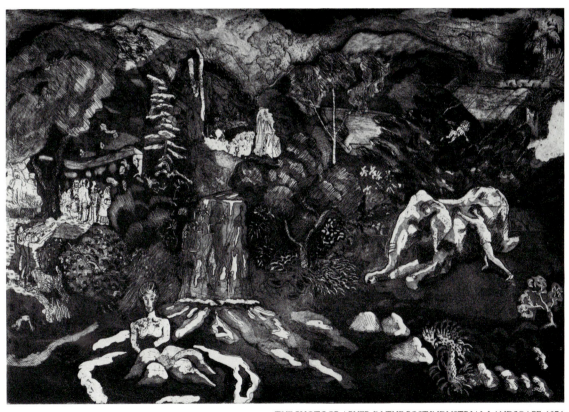

THE PHOTOGRAPHER IN THE POST-INDUSTRIAL LANDSCAPE, 1976
Collection of the artist (Cat. no. 110)
(Left) Detail of the above

NATIONAL DEFENSE: EVERY BODIES DREAM: SECOND SERIES,
1981
Collection of the artist (Cat. no. 171)

(Right)
ANTHROPOLOGICAL PHOTO DOCUMENTATION, ca. 1970
Collection of Harold Jones, Tucson, AZ (Cat. no. 68)

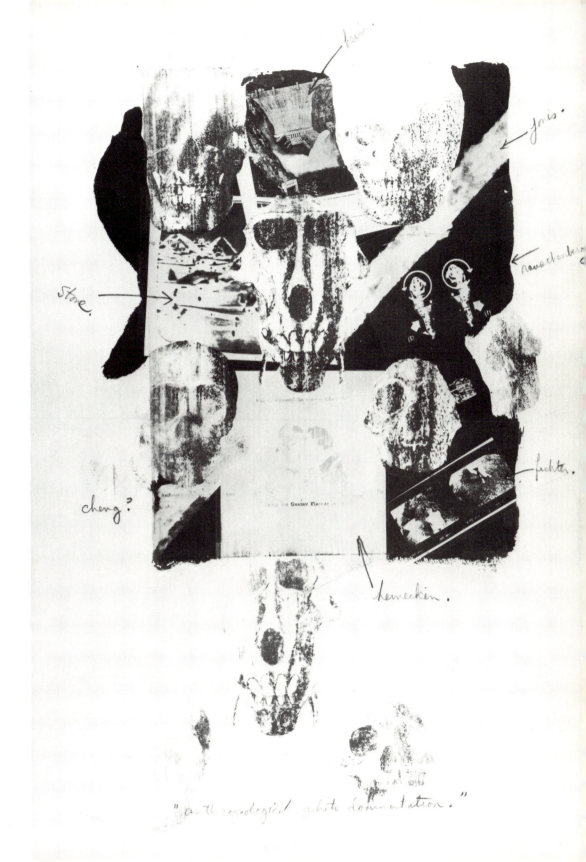

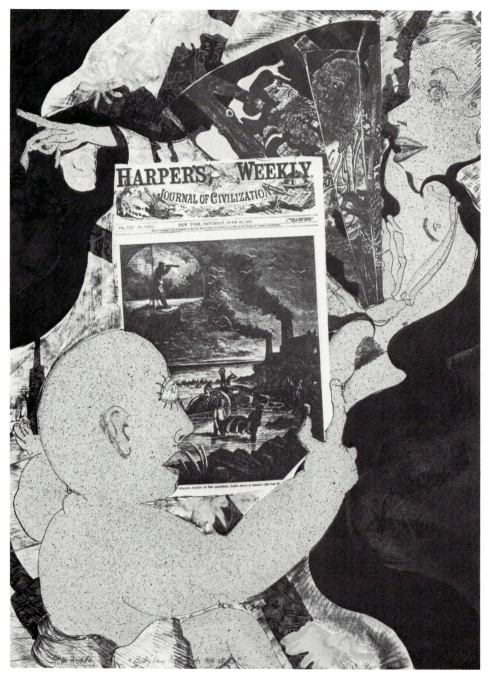

BABY GENE POOL GETS THE NEWS, ca. 1980
Collection of the artist (Cat. no. 134)

SPEAKING OF SURVIVAL . . . , 1980
Collection of the artist (Cat. no. 152)

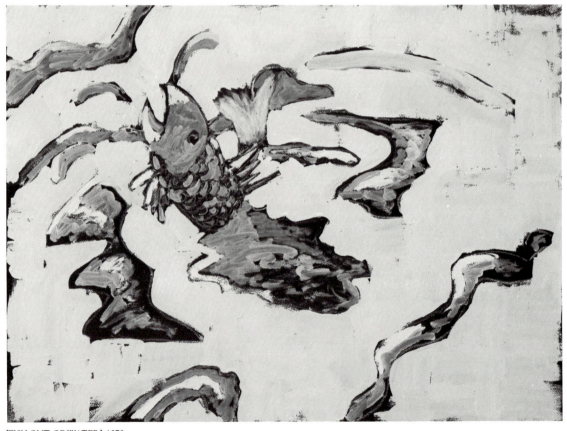

[FISH OUT OF WATER], 1979
Collection of the artist (Cat. no. 123)

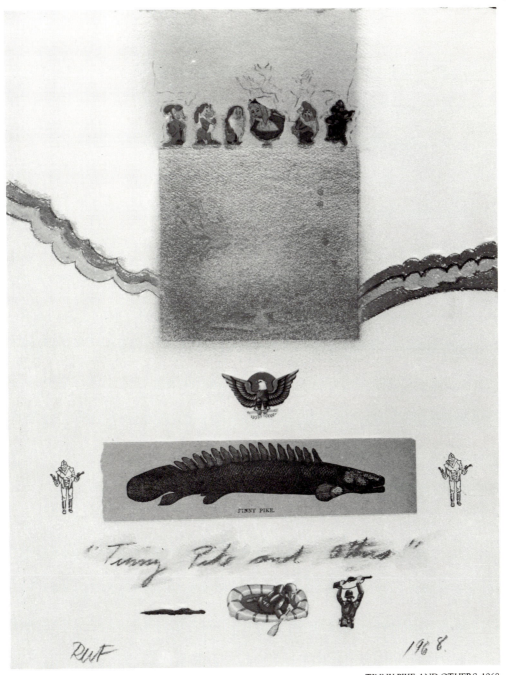

TINNY PIKE AND OTHERS, 1968
Collection of Harold Jones, Tucson, AZ (Cat. no. 42)

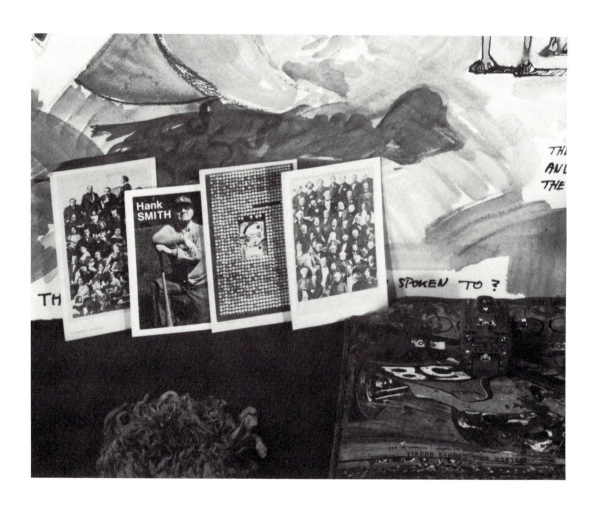

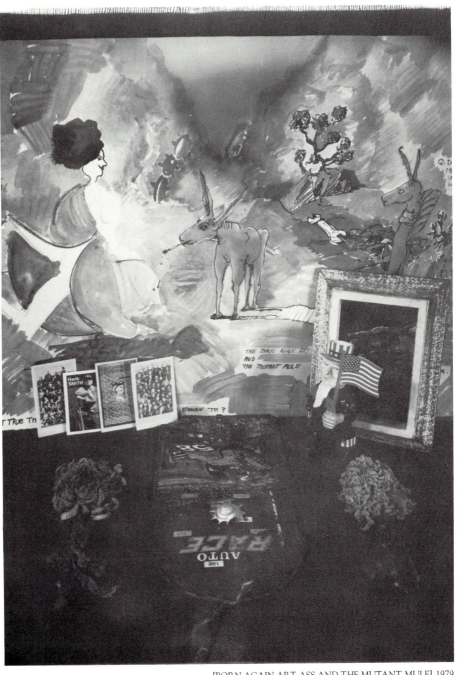

[BORN AGAIN ART ASS AND THE MUTANT MULE], 1979
Collection of the artist (Cat. no. 118)

(Left) Detail of the above

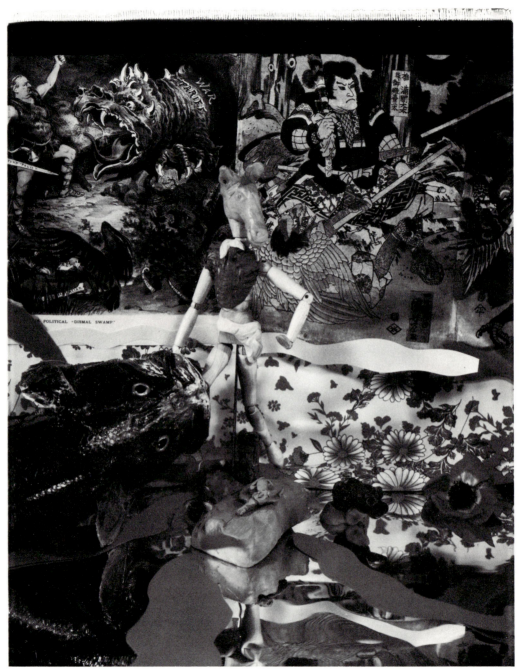

DISMAL SWAMP #1, 1980
Collection of the artist (Cat. no. 140)

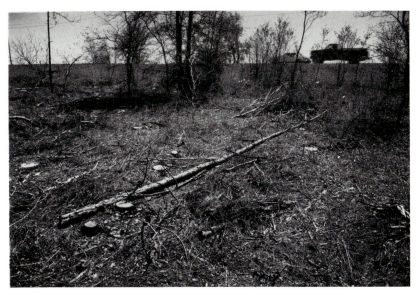

FELLED IMMATURE PINE WITH CAR AND TRUCK,
TALLAHASSEE, FLORIDA, 1981
Collection of the artist (Cat. no. 166)

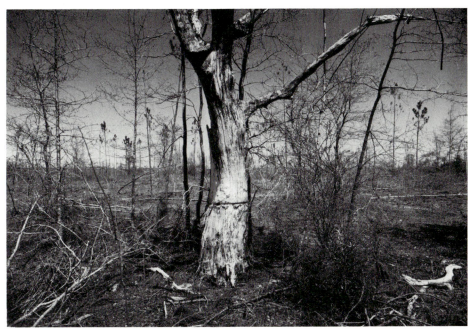

GIRDED OAK–ST. JOE PAPER COMPANY LAND–TRUCK RT.,
TALLAHASSEE, FLORIDA, 1981
Collection of the artist (Cat. no. 168)

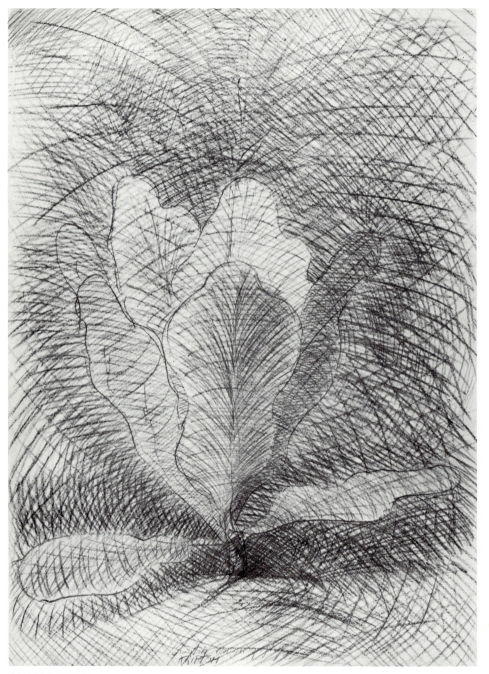

COLLARD #2, 1979
Collection of the artist (Cat. no. 121)

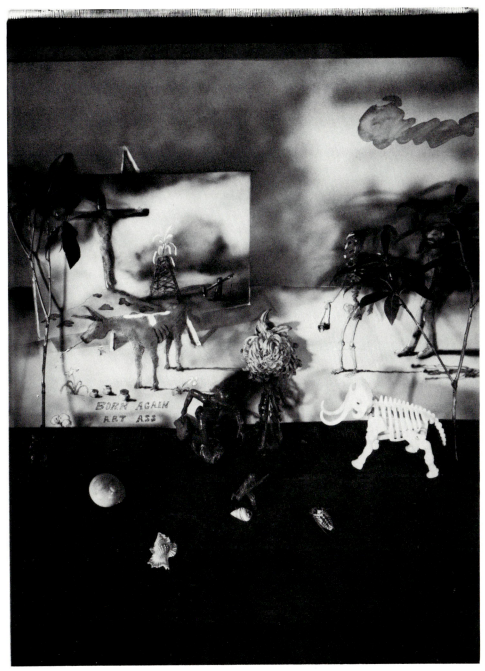

[MASTODON SKELETON, BORN AGAIN ART ASS, AND MR.
BONES], 1979
Collection of the artist (Cat. no. 124)

SELECTED BIBLIOGRAPHY

Publications by the artist
—"Alice Andrews," *Creative Camera*, 62 (August 1969), 282-285.
—*Know Where to Look*, Chicago, n.d. (ca. 1977).
—"Afterward," in S. L. Berens (ed.), *Altered Landscapes*, exhibition catalogue, Florida School of the Arts, Palatka, 1978, unp.
—*The Confessions of a Silver Addic! or, Silver IS Quicker*, n.p. (Covington, KY), n.d. (1979).

Articles on the artist
Barrow, T. F., "Learning from the Past," in J. Alinder (ed.), *9 Critics, 9 Photographs (Untitled 23)*, Carmel, CA, 1980, 32-36.
Barrow, T. F. "Robert Fichter's Puns and Anagrams," introduction to *Robert Fichter*, slide set, n.p. (Rochester, NY), 1973, unp.
Coke, V. D., "60's Continuum," *Image*, XV, 1 (March 1972), 1-6.
Cowin, E. "On Robert Fichter," *Working Papers*, 3 (May 1982), 14.
Fisher, H., "Charles Traub and Robert Fichter," *Artweek*, IX, 30 (16 September 1978), 11-12.
Jenkins, W., "Robert Fichter," *Northlight*, (in preparation), 1982.

Portfolios containing work by the artist
California State College, *Graphic/Photographic*, Fullerton, 1971.
School of the Art Institute of Chicago, *Underware*, Chicago, 1976.
Los Angeles Center for Photographic Studies, *Silver Sea*, Los Angeles, 1977.
Florida State University, *Souvenir of Florida*, Tallahassee, 1978.
Paradox Editions and RFG Publishing, *Five Still Lives*, New York, 1980.
University of Florida, *Orange Blossom Special*, Gainesville, 1980.
Landweber/Artists, *American Roads*, Los Angeles, (in preparation).

CHRONOLOGY

	
1939	Born, Ft. Myers, FL.
1959-63	University of Florida, Gainesville, B.F.A., painting and printmaking, studied with Ken Kerslake (printmaking), Jack Nichelson (design), Jerry N. Uelsmann (photography), and Hiram Williamson (painting).
1963-66	Indiana University, Bloomington, M.F.A., printmaking and photography, studied with James McGarrell (painting), and Henry Holmes Smith (photography).
1966-68	Assistant Curator of Exhibitions, George Eastman House Museum, Rochester, NY, worked with Nathan Lyons.
1967	Visiting Instructor, University of Florida, Gainesville.
1968 (summer)	Faculty position, Penland School of Crafts, Penland, NC.
1968	One-man exhibition, "Robert Fichter's Trips," George Eastman House.
1968-70	Assistant Professor, University of California, Los Angeles.
1970 (summer)	Faculty position, Penland School of Crafts, Penland, NC.
1970	One-man exhibition, "Recent Photo Drawings," University of California, Davis.
1970	Group exhibitions: "The Photograph as Object, 1843-1969," National Gallery of Canada, Ottawa; "California Photography 1970," University of California, Davis.
1971	Lecturer, University of California, Los Angeles.
1971 (summer)	Faculty position, Penland School of Crafts, Penland, NC.
1971	Group Exhibitions: "Opening Exhibition," Ohio Silver Gallery, Los Angeles; "13 Photographers," Light Gallery, NY.
1972-76	Assistant Professor, Florida State University, Tallahassee.
1972	One-man exhibitions: Center of the Eye, Aspen, CO; Visual Studies Workshop, Rochester, NY.
1972	Group exhibition: "60's Continuum," George Eastman House, Rochester, NY.
1973	Group exhibitions: "13 Contemporary Photographers," Texas Technological College, Lubbock; "Recent Acquisitions," George Eastman House, Rochester, NY; "Lens and Light," Hudson River Museum, Yonkers, NY.
1974	One-man exhibition, Light Gallery, NY.
1974	Group exhibitions: "Contemporary Photography from the Collections," Museum of Fine Arts, Boston, MA; "Photography Unlimited," Fogg Museum, Harvard University, Cambridge, MA.
1975	One-man exhibition, University of New Mexico Art Gallery, Albuquerque, NM.
1975	Group exhibitions: "History Transformed: History of Photography in Subject Matter," Friends of Photography, Carmel, CA; "New American Graphics," Madison Art Center, Madison, WI; "Robert Fichter, Todd Walker, John Wood," Visual Studies Workshop, Rochester, NY.
1976–present	Associate Professor, Florida State University, Tallahassee.
1976	Visiting Associate Professor, University of California, Los Angeles.
1976	One-man exhibition, Light Gallery, NY.
1976	Group exhibitions: "New Blues," Arizona State University, Tempe; "Artists' Biennial," New Orleans Museum of Art, New Orleans, LA; "Exposing Photographic Definitions," Los Angeles Institute of Contemporary Art, Los Angeles, CA.
1977	Visiting Artist, School of the Art Institute of Chicago, Chicago, IL.
1977	Group Exhibition: "Painting in the Age of Photography,"

CATALOGUE TO EXHIBITION

Kunsthaus, Zurich, Switzerland.

1978 One-man exhibition, Camerawork, San Francisco, CA.

1978 Group exhibitions, "The Art of Offset Printing," School of the Art Institute of Chicago, Chicago, IL.

1979 Group exhibitions: "20x24 Polaroid," Light Gallery, NY; "My Teacher, My Self," Susan Spiritus Gallery, Newport Beach, CA.

1980 One-man exhibitions: Robert Freidus Gallery, NY; Gulf Coast Gallery, Tampa, FL; Northlight Gallery, Tempe, AZ.

1980 Group exhibitions: "Invented Images," University of California, Santa Barbara, CA; "Vis à Vis/Art & Photography," Art Institute, Boston, MA; "Aspects of the 70's: Photography: Recent Directions," DeCordova and Dana Museum, Lincoln, MA; "Silver Interactions," University of South Florida, Tampa; "Graphics Invitational," Mint Museum, Charlotte, NC; "Birds," Museum of Modern Art, NY.

1981 One-man exhibition, Robert Freidus Gallery, NY.

1981 Group exhibitions: "Whitney Biennial," Whitney Museum, NY; "Acquisitions 1973-1980," International Museum of Photography at George Eastman House, Rochester, NY.

NOTE:

The work of Robert W. Fichter presents a number of problems in how to catalogue it in a useful and logical fashion. To arrange the works by discrete themes or specific subjects would be impossible since the artist very often combines and recombines his iconography in ways that would necessitate an elaborate system of cross-referencing. Similarly, while a systematic outlining of the various processes and/or techniques used by Fichter may have been edifying to many readers, his repeated combinations of multiple materials would have yielded an overly confusing array of terminologies. In the end, it was decided to catalogue the work in a strictly chronological manner, thereby allowing the reader to review and follow the artist's overall growth and development with both themes and materials.

Titles of works are presented straightforwardly and when the work clearly lacks a title, a brief, synoptic description is supplied within square brackets. Labeling of processes is limited to the strictly physical materials and techniques of the print or work; therefore solarization of a photographic print is included, but whether the image is from a multiply exposed negative or a "straight" print is not. In metric measurements, dimensions are given with height preceding width.

1.
ALLEGORY OF DOUBTFUL MEANING
1962
Gelatin silver print
24.8 x 19.2 cm
Collection of Alisa Wells on permanent loan
 to Visual Studies Workshop, Rochester, NY

2.
LOOK OUT STEVE! THERE'S SOMETHING IN FRONT OF YOUR FACE
1964
Gelatin silver print
17.9 x 18.1 cm
Collection of Alisa Wells on permanent loan
 to Visual Studies Workshop, Rochester, NY

3.
[SELF-PORTRAIT IN CAR]
1964
Gelatin silver print
25.7 x 26.5 cm
Collection of the artist

4.
[STEVE WITH ALOE PLANT]
1964
Gelatin silver print
17.7 x 16.2 cm
Collection of Alisa Wells on permanent loan
 to Visual Studies Workshop, Rochester, NY

5.
BELIEVE ME. I DO NOT WISH THAT
 YOU SHOULD NOTICE MY
 CONSTANT ARROW
1966
Lithographic print with offset newsprint and
 transparent adhesive tape
54.1 x 39.4 cm
Collection of the artist

6.
[BRAIN CORAL]
ca. 1966
Gelatin silver print
10.8 x 16.3 cm
Collection of Alisa Wells on permanent loan
 to Visual Studies Workshop, Rochester, NY

7.
RWF MFA THESIS EXHIBITION:
 NOTES FROM A BIOLOGICAL AND
 PSYCHOLOGICAL GARDEN
1966
Lithographic print, ed. 3/4
30.5 x 19.0 cm
Collection of Alisa Wells on permanent loan
 to Visual Studies Workshop, Rochester, NY

8.
[TWO FIGURES IN LANDSCAPE]
1966
Lithographic print
24.1 x 33.0 cm
Collection of Alisa Wells on permanent loan
 to Visual Studies Workshop, Rochester, NY

9.
WHOSE DOG IS THAT?
1966
Intaglio print (etching and aquatint), ed. 3/3
24.1 x 27.8 cm
Collection of the artist

10.
[TWO DOGS AND ARROW]
ca. 1966
Lithographic print, ed. 2/6
24.8 x 19.7 cm
Collection of Alisa Wells on permanent loan
 to Visual Studies Workshop, Rochester, NY

11.
[FEMALE FIGURE]
ca. 1966
From: series, *Dianagrams*
Gelatin silver print
23.6 x 32.4 cm
Collection of Aliśa Wells on permanent loan
 to Visual Studies Workshop, Rochester, NY
(*Illustrated*)

12.
[FEMALE FIGURE AND LAWN CHAIRS]
ca. 1966
From: series, *Dianagrams*
Gelatin silver print
22.0 x 31.9 cm
Collection of Aliśa Wells on permanent loan
 to Visual Studies Workshop, Rochester, NY
(*Illustrated*)

13.
[FEMALE FIGURE AND SELF PORTRAIT]
ca. 1966
From: series, *Dianagrams*
Gelatin silver print, solarized
22.0 x 31.9 cm
Collection of Aliśa Wells on permanent loan
 to Visual Studies Workshop, Rochester, NY
(*Illustrated*)

14.
[FEMALE FIGURE AND SHOES]
ca. 1966
From: series, *Dianagrams*
Gelatin silver print, solarized
22.0 x 32.3 cm
Collection of Aliśa Wells on permanent loan
 to Visual Studies Workshop, Rochester, NY
(*Illustrated*)

15.
[TWO SUN BATHERS ON LAWN]
ca. 1966
From: series, *Dianagrams*
Gelatin silver print
21.7 x 32.0 cm
Collection of Aliśa Wells on permanent loan
 to Visual Studies Workshop, Rochester, NY

16.
[TWO SUNBATHERS AND SHOES]
ca. 1966
From: series, *Dianagrams*
Gelatin silver print
21.7 x 31.8 cm
Collection of Aliśa Wells on permanent loan
 to Visual Studies Workshop, Rochester, NY

17.
[AIR STREAM TRAILER AND LAWN
 CHAIR]
1967
From: series, *Road Shots*
Gelatin silver print
21.8 x 31.4 cm
Collection of the artist
(*Illustrated*)

18.
[BULLFIGHT SCENE]
1967

Gelatin silver print with water color
24.5 x 34.3 cm
Collection of Robert Heinecken, Culver City,
 CA and Chicago, IL

19.
[DOGS IN KENNEL RUN]
1967
Gelatin silver print, solarized
24.0 x 31.7 cm
Collection of the artist
(*Illustrated*)

20.
[DOG IN ROAD]
1967
Gelatin silver print
19.6 x 24.1 cm
Collection of the artist

21.
[DRIVER AND ROAD]
1967
Gelatin silver print, solarized
11.0 x 34.2 cm
Collection of the artist
(*Illustrated*)

22.
[FIGURE IN FRONT OF WALL (SELF
 PORTRAIT?)]
1967
Gelatin silver print
19.4 x 19.0 cm
Collection of Aliśa Wells on permanent loan
 to Visual Studies Workshop, Rochester, NY
(*Illustrated*)

23.
[HORSE IN TRUCK]
1967
From: series, *Road Shots*
Gelatin silver print, solarized
25.2 x 31.5 cm
Collection of the artist
(*Illustrated*)

24.
LARGE UNFINISHED SPEACH FOR
 ALICE
1967
Graphite and oil crayon on paper
45.1 x 60.3 cm
Collection of Aliśa Wells on permanent loan
 to Visual Studies Workshop, Rochester, NY

25.
[ROAD GANG BESIDE HIGHWAY]
1967
From: series, *Road Shots*
Gelatin silver print
21.7 x 31.4 cm
Collection of the artist
(*Illustrated*)

26.
[STREET SCENE, ROCHESTER, NY]
1967
Gelatin silver print
22.3 x 28.7 cm
Collection of the artist

27.
[DOG]
ca. 1967
Graphite, paint, oil crayon on paper
66.5 x 50.3 cm
Collection of the artist
(*Illustrated*)

28.
[FIGURE AND TREES IN LANDSCAPE]
ca. 1967
Gelatin silver print with color dye
7.9 x 22.1 cm
Collection of Aliśa Wells on permanent loan
 to Visual Studies Workshop, Rochester, NY

29.
[GIANT SNAKES/ADVENTURE]
ca. 1967
Gelatin silver print, solarized
26.9 x 34.3 cm
Collection of the artist

30.
HAS BEEN HERE
ca. 1967
Gelatin silver print
22.2 x 32.3 cm
Collection of the artist

31.
KING
ca. 1967
Gelatin silver print
16.3 x 23.5 cm
Collection of the artist

32.
[NUDE AND TRAILER]
ca. 1967
Gelatin silver print
17.4 x 25.6 cm
Collection of Roger Mertin, Rochester, NY
(*Illustrated*)

33.
[SKULL IN FOLIAGE]
ca. 1967
Gelatin silver print
21.5 x 30.4 cm
Collection of the artist
(*Illustrated*)

34.
[VEILED NUDE]
ca. 1967
Gelatin silver print
16.3 x 16.2 cm
Collection of Roger Mertin, Rochester, NY

35.
[WOMAN IN WOODED GROTTO]
ca. 1967
Gelatin silver print with color dye
18.1 x 35.0 cm
67:112:1
Collection of International Museum of
 Photography at George Eastman House;
 Museum purchase

36.
DEEP SEA DIVER WITH AMAZING EYE
 FOR BUTTERFLY

1968
From: series, *Assination* [sic] *of Butterfly*
Oil crayon, transfers, offset print, ink
 stampings and graphite on paper
35.3 x 26.5 cm
Collection of Mr. and Mrs. Thomas F. Barrow,
 Albuquerque, NM
(*Illustrated*)

37.
DOUBLE ROCHESTER VISION
1968
Gelatin silver print
13.2 x 34.0 cm
Collection of Todd Walker, Tucson, AZ

38.
[LOVE IS LIKE SO MANY OTHER
 MYSTERIES: WEAIRD!]
1968
Graphite, ink stamping and oil crayon on paper
Private collection
(*Illustrated*)

39.
NATIONAL DEFENSE METAPHOR NO.
 20001
1968
Gelatin silver print with rub-on transfer and
 water color
21.4 x 31.9 cm
Collection of Roger Mertin, Rochester, NY

40.
PISTON VISION NO. 1
1968
Water color, oil crayon and graphite on paper
27.6 x 37.0 cm
Private collection

41.
SAMPLER NO. 1
1968
Ink stamping, graphite and oil crayon on paper
26.5 x 34.2 cm
Collection of the artist

42.
TINNY PIKE AND OTHERS
1968
Steel engraving, ink stamping, transfers, oil
 crayon, graphite and paint on paper
33.1 x 25.4 cm
Collection of Harold Jones, Tucson, AZ
(*Illustrated*)

43.
[WOMAN WITH CAMERA]
1968
Gelatin silver print, solarized
12.5 x 34.0 cm
Collection of Alisa Wells on permanent loan
 to Visual Studies Workshop, Rochester, NY

44.
YELLOW BAND AID
1968
Oil crayon, water color, ink stampings,
 transfers, offset prints and graphite on paper
50.8 x 60.7 cm
Collection of Mr. and Mrs. Thomas F. Barrow,
 Albuquerque, NM (*Illustrated*)

45.
BUTTERFLY ASSINATION NUMBER 2
1969
Graphite with applied decals on paper
35.4 x 31.8 cm
Collection of Todd Walker, Tucson, AZ

46.
CHINESE NATURALIST PRINT NO. 1
1969
Verifax print with water color
33.1 x 21.3 cm
Collection of the artist

47.
D FORD, SIDEWALK
1969
Gelatin silver print with applied decals, plastic
 labels and ink stampings
13.8 x 7.7 cm
Private collection

48.
CHICK
1969
Gelatin silver print with applied decals, plastic
 labels and ink stampings
13.8 x 7.7 cm
Private collection

49.
MARGI AT THE SEA SHORE
1969
Verifax transfer print with water color,
 graphite and applied decal
21.3 x 33.2 cm
Collection of Virgil Mirano, Venice, CA

50.
NATIONAL DEFENSE METAPHOR
1969
Cyanotype print with oil crayon, graphite,
 transfers and ink stamp
28.0 x 21.6 cm
70:0070:4
Collection of International Museum of
 Photography at George Eastman House;
 Museum purchase
(*Illustrated*)

51.
NATURE'S OWN EYE LOOKS BACK
1969
Cyanotype print with graphite, ink stamping,
 and butterfly
20.4 x 24.3 cm
Collection of the artist, courtesy of Visual
 Studies Workshop, Rochester, NY
(*Illustrated*)

52.
PHOTO BY PHICTER
1969
Gelatin silver print with applied decals and
 plastic labels
13.8 x 7.7 cm
Private collection

53.
PHOTO-DOCUMENTATION
1969
Verifax transfer and cyanotype print with

water color and graphite
32.7 x 50.9 cm
Collection of Roger Mertin, Rochester, NY
(*Illustrated*)

54.
THE SOLDIER IS FIXING THE REAR
 SIGHT OF HIS RIFLE SO THAT THE
 BULLET WILL GO STRAIGHT TO
 THE TARGET
1969
Verifax transfer and cyanotype print with
 water color and applied decals
29.7 x 21.3 cm
70:070:5
Collection of International Museum of
 Photography at George Eastman House;
 Museum purchase

55.
THIS PICTURE SPOT RECOMENDED
1969
Cyanotype print
44.0 x 32.1 cm
Collection of the artist
(*Illustrated*)

56.
[WORLD WAR I SOLDIERS]
1969
Cyanotype print with water color and ink
 stamping
35.5 x 45.7 cm
Collection of Jerry N. Uelsmann,
 Gainesville, FL
(*Illustrated*)

57.
[WORLD WAR I SOLDIERS AND
 RHINOCEROS]
1969
Cyanotype print with oil crayon, graphite,
 applied decal and water color
50.6 x 35.3 cm
Collection of the artist, courtesy of Robert
 Freidus Gallery, New York

58.
BASIC FLESH COMES TO LAX
ca. 1969
Gelatin silver print, with water color, plastic
 labels
20.5 x 12.7 cm
73:0064:1
Collection of International Museum of
 Photography at George Eastman House;
 Gift of the artist

59.
[APOCALYPTIC LANDSCAPE AND
 TURTLES]
1970
Cyanotype and gum-bichromate print
49.9 x 32.2 cm
Collection of the artist
(*Illustrated*)

60.
["DEAR ALICE . . ."]
1970
Gelatin silver print

7.9 x 23.2 cm
Collection of Alisa Wells on permanent loan
 to Visual Studies Workshop, Rochester, NY
(*Illustrated*)

61.
GERONIMO (APACHE: SOUTHWEST)
 WITH FOLD MARK
1970
Gum-bichromate print with applied decals, oil
 crayon, offset print and graphite
32.5 x 50.2 cm
71:003:1
Collection of International Museum of
 Photography at George Eastman House;
 Gift of the artist

62.
GOOD GRIEF RAINBOW STAR FIELD
1970
Cyanotype and verifax print with water color,
 oil crayon, graphite and ink stamping
32.5 x 50.6 cm
Collection of the artist

63.
RHINO DEN PIN UP NO. 123
1970
Cyanotype and gum-bichromate print with ink
 stamping
50.1 x 32.5 cm
Collection of the artist, courtesy of Visual
 Studies Workshop, Rochester, NY

64.
ROAST BEAST/WEAPON OF WAR
1970
Cyanotype and gum-bichromate print
50.1 x 32.3 cm
Collection of the artist
(*Illustrated*)

65.
[TWO FIGURES IN CIRCULAR
 LANDSCAPE/MAN WITH HANDS
 ON HEAD]
1970
Cyanotype and gum-bichromate print
50.1 x 32.7 cm
Collection of the artist, courtesy of Visual
 Studies Workshop, Rochester, NY

66.
[TWO STRIPS OF IMAGE PATCHES]
1970
Cyanotype print
49.8 x 32.3 cm
Collection of the artist

67.
[WORLD WAR I SOLDIERS AND
 WOMAN IN SPHERE]
1970
Cyanotype and gum-bichromate print
50.4 x 32.5 cm
Collection of the artist

68.
ANTHROPOLOGICAL PHOTO
 DOCUMENTATION
ca. 1970
Verifax transfer and cyanotype print

50.4 x 32.7 cm
Collection of Harold Jones, Tucson, AZ
(*Illustrated*)

69.
[ASTRONAUTS AND WORLD WAR I
 SOLDIERS]
ca. 1970
Cyanotype and gum-bichromate print
88.0 x 49.0 cm
74:222:4
International Museum of Photography at
 George Eastman House; Museum purchase
 with National Endowment for the Arts
 support
(*Illustrated*)

70.
[DOG, WOMAN AND FIGURE]
ca. 1970
Silver gelatin print, solarized
35.2 x 27.8 cm
74:136:1
International Museum of Photography at
 George Eastman House; Museum purchase
 with National Endowment for the Arts
 support

71.
[SIX IMAGE PATCHES/NINE ARTISTS]
ca. 1970
Cyanotype print with graphite
32.4 x 49.1 cm
Collection of the artist

72.
[BROWNIE TARGET CAMERA AND
 WORLD WAR I SOLDIERS]
1971
Cyanotype and gum-bichromate print
70.0 x 49.0 cm
74:222:3
International Museum of Photography at
 George Eastman House; Museum purchase
 with National Endowment for the Arts
 support

73.
DOUBLE PLANE TANK
1971
Cyanotype and gum-bichromate print
64.8 x 51.1 cm
Collection of the artist

74.
[FIGURE IN LANDSCAPE WITH FIVE
 TURTLES]
1971
Cyanotype and gum-bichromate print with
 graphite, and water color
50.3 x 60.2 cm
74:222:1
International Museum of Photography at
 George Eastman House; Museum purchase
 with National Endowment for the Arts
 support

75.
FLORIDA BOMB SITES
1971
From: series, *The Dream of Perpetual War*

Verifax transfer print with water color
65.3 x 102.0 cm
Collection of the artist
(*Illustrated*)

76.
NO. 1 MAGIC PRINT PAPER
1971
From: series, *Place Magic Print Paper*
Verifax transfer print with water color and
 colored pencil
31.9 x 40.2 cm
Collection of the artist

77.
NO. 2 MAGIC PRINT PAPER
1971
From: series, *Place Magic Print Paper*
Verifax transfer print with colored pencil
34.6 x 40.3 cm
Collection of the artist

78.
[MALE FIGURE IN LANDSCAPE AND
 HAND]
1971
Offset photomechanical print
32.7 x 24.5 cm
Private collection

79.
[NEGATIVE FIGURE AND MOONSCAPE]
1971
Cyanotype and gum-bichromate print
64.6 x 50.6 cm
Collection of the artist
(*Illustrated*)

80.
TURTLETESTS
1971
From: portfolio, *Graphic/Photographic*,
 California State College, Fullerton, 1971
Offset photomechanical print
30.5 x 19.0 cm
Private collection

81.
[DOGS ON BEACH]
1973
Gelatin silver print, solarized
40.3 x 50.6 cm
Collection of the artist, Courtesy of Robert
 Freidus Gallery, New York
(*Illustrated*)

82.
[FEMALE FIGURE AND LANDSCAPE]
1973
Gelatin silver print, solarized
50.7 x 40.3 cm
Collection of the artist

83.
LADY WITH GATORS
1973
Inko dye print
60.7 x 60.9 cm
Collection of the artist
(*Illustrated*)

84.
MARTIN B-26B-55
1973
Verifax transfer print with colored pencil and
 transfers
58.8 x 80.3 cm
Collection of the artist
(*Illustrated*)

85.
MYSTERY GUN
1973
Gelatin silver print, solarized
40.3 x 50.7 cm
Collection of the artist
(*Illustrated*)

86.
PAGE 1
1973
From: series, *The Tallahassee Democrat*
Verifax transfer print with colored pencil and
 graphite
60.5 x 40.8 cm
Collection of the artist

87.
PAGE 4
1973
From: series, *The Tallahassee Democrat*
Verifax transfer print with colored pencil and
 graphite
60.5 x 40.0 cm
Collection of the artist

88.
PHOTO INFO NO. 2
1973
Inko dye print
50.6 x 60.2 cm
Collection of the artist
(*Illustrated*)

89.
[SELF-PORTRAIT WITH HERON]
1973
Gelatin silver print, solarized
40.3 x 50.6 cm
Collection of the artist
(*Illustrated*)

90.
[SWAMP LANDSCAPE]
1973
Cyanotype print with water color
72.1 x 53.0 cm
Collection of The Art Museum, Princeton
 University, Princeton, NJ, National
 Endowment for the Arts and
 Anonymous gift

91.
[TURTLES AND DOLL]
1973
Verifax transfer print with Inko dye
62.0 x 80.6 cm
Collection of the artist

92.
[UNIVERSAL STUDIOS BACKLOT]
1973
Cyanotype print with water color

64.7 x 50.5 cm
Collection of the artist

93.
[WARNING/DON'T FEED THE
 ALLIGATORS/FLORIDA]
1973
Verifax transfer print with water color
60.7 x 40.7 cm
Collection of the artist
(*Illustrated*)

94.
WESTERN LANDSCAPE
1973
Inko dye print
50.8 x 60.2 cm
Collection of the artist

95.
[CIVIL WAR SOLDIERS AND
 MOONSCAPE]
1974
Lacquer transfer 3M-VSQ copier print with
 water color
75.8 x 56.4 cm
Collection of the artist
(*Illustrated*)

96.
[1930's MOTHER AND MACHU PICHU
 LANDSCAPE]
1974
Lacquer transfer 3M-VSQ copier print with
 water color
56.3 x 75.8 cm
Collection of the artist

97.
MOONRISE
1974
Lacquer transfer 3M-VSQ copier print with
 water color
56.3 x 75.6 cm
Collection of Virgil Mirano, Venice, CA

98.
DAGUERRIAN ERROR
1975
Intaglio print (etching)
32.3 x 24.1 cm
Collection of the artist
(*Illustrated*)

99.
OKRA
1975
From: series, *War Memorial*
Cyanotype print with tempera, water color and
 colored pencil
91.7 x 64.5 cm
Collection of the artist

100.
PEACE IN THE KINGDOM
1975
From: series, *War Memorial*
Cyanotype print with tempera and water color
64.9 x 99.8 cm
Collection of the artist
(*Illustrated*)

101.
[PORTRAIT OF EILEEN]
1975
Cyanotype print with water color
82.0 x 30.2 cm (triptych)
Collection of Eileen Cowin, Venice, CA

102.
[RAM'S HEAD AND NUDE]
1975
Gelatin silver print, solarized
35.3 x 27.7 cm
Collection of the artist
(*Illustrated*)

103.
SOLDIER'S DELIGHT
1975
From: series, *War Memorial*
Cyanotype print with tempera and water color
63.1 x 100.00 cm
Collection of the artist
(*Illustrated*)

104.
[FIGURES IN BAMBOO]
ca. 1975
Gelatin silver print
39.8 x 40.2 cm
Collection of the artist

105.
[FIGURES IN BAMBOO]
ca. 1975
Gelatin silver print
39.8 x 39.6 cm
Collection of the artist

106.
[SELF-PORTRAIT]
ca. 1975
Gelatin silver print, solarized
40.3 x 50.6 cm
Collection of the artist

107.
[COWS IN LANDSCAPE]
1976
Intaglio print (etching and aquatint)
59.3 x 73.0 cm
Collection of the artist
(*Illustrated*)

108.
THE MACHINE IN THE GARDEN
1976
From: portfolio, *Underware*, School of the Art
 Institute of Chicago, 1976
Gelatin silver print, ed. 2/50
41.0 x 55.6 cm
77:048:1
International Museum of Photography at
 George Eastman House; Museum purchase

109.
MECHO-VIEW: AL B QUE NO. 3
1976
Colored Xerox transfer print with colored
 pencil
66.0 x 50.9 cm
Collection of the artist

110.
THE PHOTOGRAPHER IN THE
 POST-INDUSTRIAL LANDSCAPE
1976
Intaglio print (etching and aquatint)
60.5 x 89.0 cm
Collection of the artist
(*Illustrated*)

111.
EROTIC LANDSCAPE WITH FIGHTER
ca. 1976
Water color and ink on paper
39.5 x 50.7 cm
Collection of the artist, courtesy of Robert
 Freidus Gallery, New York
(*Illustrated*)

112.
NOW
ca. 1976
Water color, tempera and ink on paper
37.8 x 53.2 cm
Collection of the artist
(*Illustrated*)

113.
THEN
ca. 1976
Water color, tempera and ink on paper
37.3 x 53.8 cm
Collection of the artist
(*Illustrated*)

114.
[FIGURES RUNNING IN LANDSCAPE]
1977
Intaglio print (etching)
54.7 x 60.1 cm
Collection of the artist, courtesy of Robert
 Freidus Gallery, New York

115.
ALPO
1978
Water color, ink, and oil crayon on paper
56.1 x 75.7 cm
Collection of the artist, courtesy of Robert
 Freidus Gallery, New York
(*Illustrated*)

116.
[PENZOIL CAN/LOS ANGELES POST
 CARD]
ca. 1978
Photo-silkscreen print
50.0 x 64.8 cm
Collection of the artist

117.
SING SOIL
ca. 1978
Gelatin silver print
50.7 x 40.5 cm
Collection of the artist
(*Illustrated*)

118.
[BORN AGAIN ART ASS AND THE
 MUTANT MULE]
1979
Internal dye diffusion-transfer (Polacolor) print

61.8 x 52.3 cm
Collection of the artist, courtesy of Robert
 Freidus Gallery, New York
(*Illustrated*)

119.
[BROWN IRIS]
1979
Internal dye diffusion-transfer (Polacolor) print
61.0 x 51.5 cm
Collection of the artist, courtesy of Robert
 Freidus Gallery, New York

120.
COLLARD
1979
Oil crayon on paper
80.3 x 60.9 cm
Collection of the artist, courtesy of Robert
 Freidus Gallery, New York

121.
COLLARD NO. 2
1979
Oil crayon on paper
66.3 x 48.3 cm
Collection of the artist, courtesy of Robert
 Freidus Gallery, New York
(*Illustrated*)

122.
THE FALL OF WESTERN CIVILIZATION
1979
Internal dye diffusion-transfer (Polacolor) print
61.0 x 52.3 cm
Collection of the artist, courtesy of Robert
 Freidus Gallery, New York
(*Illustrated*)

123.
[FISH OUT OF WATER]
1979
Gesso and acrylic on paper
78.1 x 106.0 cm
Collection of the artist, courtesy of Robert
 Freidus Gallery, New York
(*Illustrated*)

124.
[MASTODON SKELETON, BORN AGAIN
 ART ASS AND MR. BONES]
1979
Internal dye diffusion-transfer (Polacolor) print
65.9 x 52.2 cm
Collection of the artist, courtesy of Robert
 Freidus Gallery, New York
(*Illustrated*)

125.
NIGHT CROWN HERON
1979
Internal dye diffusion-transfer (Polacolor) print
61.3 x 52.3 cm
The Polaroid Collection, Cambridge, MA
(*Illustrated*)

126.
PENZOIL
1979
Photo-silkscreen print, ed. 1/4
79.4 x 63.3 cm
Collection of the artist, courtesy of Robert
 Freidus Gallery, New York

127.
[RED DAISY]
1979
Internal dye diffusion-transfer (Polacolor) print
61.1 x 52.5 cm
Collection of the artist, courtesy of Robert
 Freidus Gallery, New York

128.
ST. MARKS WILDLIFE REFUGE
1979
Gelatin silver print
22.5 x 29.4 cm
Collection of Betty Hahn and Daniel
 Andrews, Albuquerque, NM

129.
LACKLAND
1979-80
Internal dye diffusion-transfer (Polacolor) print
61.3 x 52.3 cm
Collection of the artist, courtesy of Robert
 Freidus Gallery, New York
(*Illustrated*)

130.
LAX SCARF PIECE
1979-80
Internal dye diffusion-transfer (Polacolor) print
61.8 x 52.3 cm
Collection of the artist, courtesy of Robert
 Freidus Gallery, New York
(*Illustrated*)

131.
WINGED FLYING DOG
1979-80
Internal dye diffusion-transfer (Polacolor) print
52.3 x 61.3 cm
Collection of the artist, courtesy of Robert
 Freidus Gallery, New York
(*Illustrated*)

132.
AFTER THE RECESSION IS OVER DO
 YOU THINK WE'LL STILL BE ABLE TO
 BUY FOOD?
1980
Lithographic print with water color and
 graphite, ed. 1/10
51.2 x 65.5 cm
Collection of the artist, courtesy of Robert
 Freidus Gallery, New York

133.
BABY GENE POOL FINDS BONES ASLEEP
 ON THE SANDS OF TIME
1980
Lithographic print with water color
51.3 x 65.1 cm
Collection of the artist, courtesy of Robert
 Freidus Gallery, New York

134.
BABY GENE POOL GETS THE NEWS
ca. 1980
Lithographic print with photo lithography, ed.
 2/25; guest edition, Print Research Facility,
 School of Art, Arizona State University;
 Joseph Segura, Master Printer
76.3 x 56.8 cm

Collection of the artist, courtesy of Robert
Freidus Gallery, New York
(*Illustrated*)

135.
BONES EXPLAINING DEATH TO FISH
OUT OF WATER
1980
Lithographic print with water color, ed. 1/10
65.4 x 50.7 cm
Collection of the artist, courtesy of Robert
Freidus Gallery, New York
(*Illustrated*)

136.
BONES EXPLAINING MASS
TRANSPORTATION AS A
COMMUNIST PLOT TO BABY GENE
POOL
1980
From: series, *Bones and Rock Garden Drawings*
Ink on paper
43.3 x 35.4 cm
Collection of the artist, courtesy of Robert
Freidus Gallery, New York

137.
BONES GOES INTO THE TIMBER
BUSINESS
1980
From: series, *Bones and Rock Garden Drawings*
Ink on paper
43.3 x 35.4 cm
Collection of the artist, courtesy of Robert
Freidus Gallery, New York

138.
BONES IN WESTERN KANSAS–YEAR
1995
1980
From: series, *Bones and Rock Garden Drawings*
Ink on paper
43.3 x 35.4 cm
Collection of the artist, courtesy of Robert
Freidus Gallery, New York

139.
DISMAL SWAMP NO. 1
1980
Internal dye diffusion-transfer (Polacolor) print
61.1 x 52.3 cm
Collection of the artist, courtesy of Robert
Freidus Gallery, New York
(*Illustrated*)

140.
DUMPSTER–NEAR SAVANNA,
GEORGIA
1980
Chromogenic development print
32.8 x 48.2 cm
Collection of the artist, courtesy of Robert
Freidus Gallery, New York

141.
EDWARD TELLER SEZ WE DID IT TO
MAKE THE WORLD SAFE FOR
DEMOCRACY!
1980
Lithographic print with water color, ed. 2/10
65.6 x 51.2 cm

Collection of the artist, courtesy of Robert
Freidus Gallery, New York
(*Illustrated*)

142.
FISH DREAM
1980
Acrylic, graphite and oil crayon on paper
61.5 x 82.0 cm
Collection of the artist, courtesy of Robert
Freidus Gallery, New York

143.
GERBER DAISIES, JAXSONVILLE,
FLORIDA
1980
From: series, *Southern Gardens*
Chromogenic development print
50.6 x 40.5 cm
Collection of the artist, courtesy of Robert
Freidus Gallery, New York

144.
GREEN FROG, WAYCROSS, GEORGIA
1980
Chromogenic development print
40.5 x 50.6 cm
Collection of the artist, courtesy of Robert
Freidus Gallery, New York

145.
[HUMMING BIRD AND ORCHID]
1980
Acrylic, oil crayon and metallic paint on paper
80.3 x 120.6 cm
Collection of the artist, courtesy of Robert
Freidus Gallery, New York

146.
THE ICE AGE COMETH! THE ICE AGE
COMETH!
1980
From: series, *Bones and Rock Garden Drawings*
Ink on paper
43.3 x 35.4 cm
Collection of the artist, courtesy of Robert
Freidus Gallery, New York

147.
IRANIAN HOSTAGE MEMORIAL NEAR
WAYCROSS, GEORGIA
1980
Chromogenic development print
40.5 x 50.6 cm
Collection of the artist, courtesy of Robert
Freidus Gallery, New York

148.
JONAH
1980
Internal dye diffusion-transfer (Polacolor) print,
ed. 9/40
63.0 x 52.2 cm
Collection of the artist, courtesy of Robert
Freidus Gallery, New York
(*Illustrated*)

149.
MR. MULE AND JONAH–THIRD
VARIATION
1980
Internal dye diffusion-transfer (Polacolor) print

63.6 x 52.0 cm
Collection of the artist, courtesy of Robert
Freidus Gallery, New York
(*Illustrated*)

150.
MR. MULE PRESENTS A TROUT
1980
Internal dye diffusion-transfer (Polacolor) print
66.6 x 52.0 cm
Photo archive of Colorado Mountain
College at Breckenridge, Breckenridge, CO
(*Illustrated*)

151.
NUDE WITH BASS
1980
Acrylic and oil crayon on paper
80.0 x 120.4 cm
Collection of the artist, courtesy of Robert
Freidus Gallery, New York
(*Illustrated*)

152.
SPEAKING OF SURVIVAL . . .
1980
Water color and ink on paper
35.3 x 27.9 cm
Collection of the artist, courtesy of Robert
Freidus Gallery, New York
(*Illustrated*)

153.
VETERAN RECRUIT NO. 3
1980
Internal dye diffusion-transfer (Polacolor) print
61.1 x 52.3 cm
Collection of the artist, courtesy of Robert
Freidus Gallery, New York
(*Illustrated*)

154.
[DEAD TREES]
ca. 1980
From: series, *Damaged Nature*
Gelatin silver print
40.5 x 50.6 cm
Collection of the artist, courtesy of Robert
Freidus Gallery, New York

155.
[FOREST SCENE]
ca. 1980
From: series, *Damaged Negative*
Gelatin silver print
40.5 x 50.6 cm
Collection of the artist, courtesy of Robert
Freidus Gallery, New York

156.
[PINE TREES]
ca. 1980
From: series, *Damaged Negative*
Gelatin silver print
40.5 x 50.6 cm
Collection of the artist, courtesy of Robert
Freidus Gallery, New York

157.
[PINE TREES]
ca. 1980
From: series, *Damaged Negative*

Gelatin silver print
40.5 x 50.6 cm
Collection of the artist, courtesy of Robert
 Freidus Gallery, New York
(Illustrated)

158.
[REFORESTED PINES]
ca. 1980
From: series, Damaged Nature
Gelatin silver print
40.5 x 50.6 cm
Collection of the artist, courtesy of Robert
 Freidus Gallery, New York
(Illustrated)

159.
[SEASCAPE]
ca. 1980
From: series, Damaged Negative
Gelatin silver print
40.5 x 50.6 cm
Collection of the artist, courtesy of Robert
 Freidus Gallery, New York
(Illustrated)

160.
[SWAMP]
ca. 1980
From: series, Damaged Nature
Gelatin silver print
40.5 x 50.6 cm
Collection of the artist, courtesy of Robert
 Freidus Gallery, New York

161.
[TREES IN LANDSCAPE]
ca. 1980
Gelatin silver print
40.5 x 50.6 cm
Collection of the artist, courtesy of Robert
 Freidus Gallery, New York

162.
[TREES IN SWAMP]
ca. 1980
From: series, Damaged Nature
Gelatin silver print
40.5 x 50.6 cm
Collection of the artist, courtesy of Robert
 Freidus Gallery, New York
(Illustrated)

163.
BONES IN TERMINAL LANDSCAPE NO. 1
1981
Chromogenic development print
40.6 x 50.7 cm
Collection of the artist

164.
CAMELLIA WITH LITTLE GREEN
 ONIONS
1981
From: series, Southern Gardens
Chromogenic development print
32.5 x 48.2 cm
Collection of the artist, courtesy of Robert
 Freidus Gallery, New York

165. a,b
[DEER AND BONES]

1981
Acrylic on paper
120.2 x 160.4 cm (diptych)
Collection of the artist, courtesy of Robert
 Freidus Gallery, New York

166.
FELLED IMMATURE PINE WITH CAR
 AND TRUCK, TALLAHASSEE,
 FLORIDA
1981
From: series, Damaged Nature
Chromogenic development print
32.2 x 48.1 cm
Collection of the artist, courtesy of Robert
 Freidus Gallery, New York
(Illustrated)

167.
[FLOWER]
1981
Colored pencil, acrylic, tempera and water
 color on paper
61.3 x 80.2 cm
Collection of the artist

168.
GIRDED OAK—ST. JOE PAPER COMPANY
 LAND—TRUCK RT., TALLAHASSEE,
 FLORIDA
1981
From: series, Damaged Nature
Chromogenic development print
32.2 x 48.4 cm
Collection of the artist, courtesy of Robert
 Freidus Gallery, New York
(Illustrated)

169.
LEMON TREE, JAXSONVILLE, FLORIDA
1981
From: series, Southern Gardens
Chromogenic development print
50.6 x 40.5 cm
Collection of the artist, courtesy of Robert
 Freidus Gallery, New York

170.
MIGHT MAKES NIGHT MANDALA
1981
From: series, Homage to El Salvador
Gelatin silver print
50.4 x 40.4 cm
Collection of the artist, courtesy of Robert
 Freidus Gallery, New York
(Illustrated)

171.
NATIONAL DEFENSE: EVERY BODIES
 DREAM: SECOND SERIES
1981
Chromogenic development print
37.4 x 47.7 cm
Collection of the artist, courtesy of Robert
 Freidus Gallery, New York
(Illustrated)

172.
NATIONAL DEFENSE: EVERY BODIES
 DREAM: SECOND SERIES
1981

Chromogenic development print
40.6 x 50.6 cm
Collection of the artist

173.
NIGHT CROWN HERON—BABY GENE
 POOL STUDIES FISHERIES
1981
From: series, KO-MO-NO Series, no. 2
Acrylic on paper
121.0 x 80.0 cm
Collection of the artist, courtesy of Robert
 Freidus Gallery, New York
(Illustrated)

174.
THE OLD WOMAN'S FLOWER GARDEN,
 SUNNILAND TERRACE,
 TALLAHASSEE, FLORIDA
1981
From: series, Southern Gardens
Chromogenic development print
32.7 x 48.2 cm
Collection of the artist, courtesy of Robert
 Freidus Gallery, New York

175.
WAR WITHOUT END
1981
Acrylic on paper
80.3 x 120.4 cm
Collection of the artist, courtesy of Robert
 Freidus Gallery, New York
(Illustrated)

176.
BONES SEZ TO BABY GENE POOL "IT'S
 JUST LIKE LIFE FLASHING BEFORE
 YOUR EYES"
1982
Lithographic print with offset
 photolithography; guest edition, Print
 Research Facility, School of Art, Arizona
 State University; Joseph Segura, Master
 Printer
55.6 x 76.0 cm
Collection of the artist
(Illustrated)

177.
BORN AGAIN ART ASS WITH CHINESE
 TANK
1982
Silver dye-bleach (Cibachrome) print
59.6 x 49.6 cm
Collection of the artist, courtesy of Robert
 Freidus Gallery, New York

178.
[FISH COSTUME]
1982
From: dance performance, The Golden Carp,
 choreographed by Nancy Smith-Fichter,
 1982
Nylon, nylon net, satin with textile paint
Cape with train
Collection of the artist (shown at IMP/GEH only)

179.
MA BELL MADONNA WITH MR. BASS
1982

Silver dye-bleach (Cibachrome) print
76.2 x 101.6 cm
Collection of the artist, courtesy of Robert
 Freidus Gallery, New York
(*Illustrated*)

180.
MR. MULE AND THE JOURNAL OF
 CIVILIZATION
1982
Silver dye-bleach (Cibachrome) print
59.6 x 49.6 cm
Collection of the artist, courtesy of Robert
 Freidus Gallery, New York

181.
WINGED DOG WITH BONES
1982
Silver dye-bleach (Cibachrome) print
49.6 x 59.6 cm
Collection of the artist, courtesy of Robert
 Freidus Gallery, New York

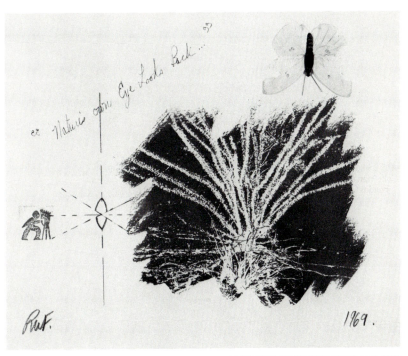

NATURE'S OWN EYE LOOKS BACK, 1969
Collection of the artist (Cat. no. 51)